UNTAMED
VERMONT

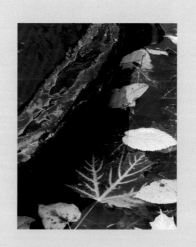

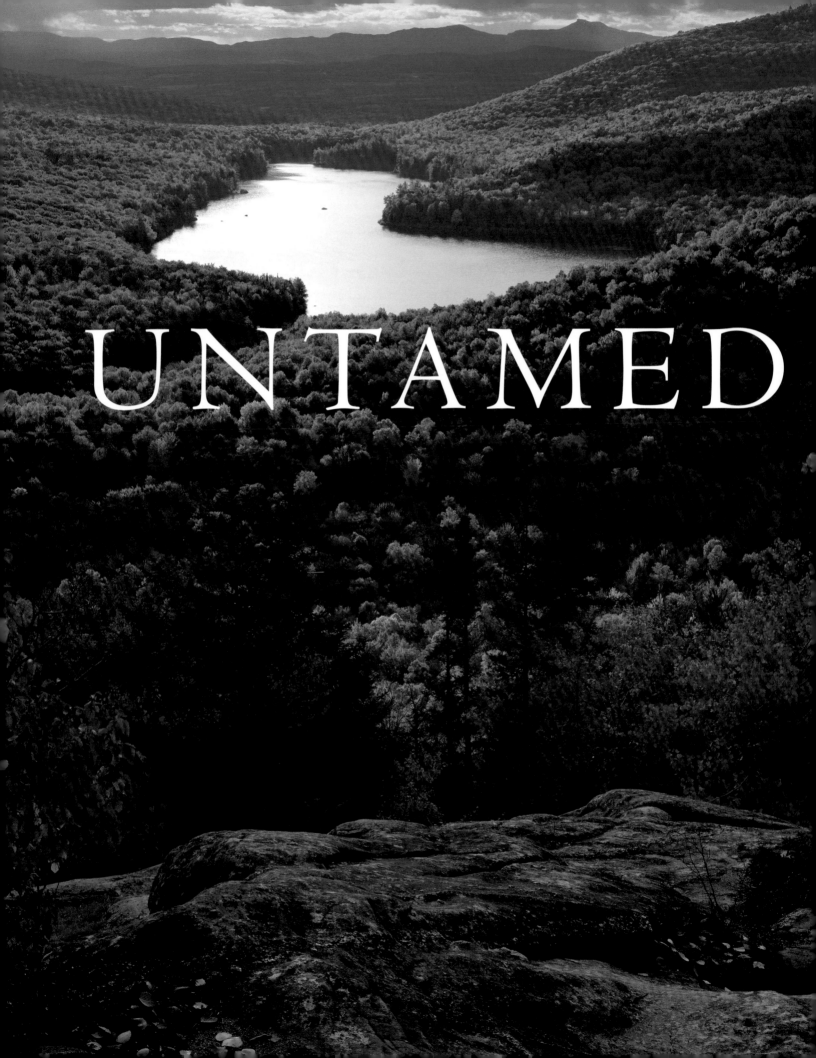

UNTAMED

PHOTOGRAPHS BY

A. BLAKE GARDNER

VERMONT

Extraordinary wilderness areas
of the Green Mountain State

COMMENTARY BY TOM WESSELS

WITH A FOREWORD BY U.S. SENATOR PATRICK LEAHY

THISTLE HILL PUBLICATIONS

Distributed by
UNIVERSITY PRESS OF NEW ENGLAND
Hanover, New Hampshire and London, England

UNTAMED VERMONT
Photographs by A. Blake Gardner

Foreword by Senator Patrick Leahy
Commentary by Tom Wessels

Captions: A. Blake Gardner

Copy Editing: Ellen K. Coughlin

Design: The Laughing Bear Associates, Montpelier, Vermont

Printing: Villanti & Sons, Milton, Vermont
 (Special thanks to Jay Villanti, Matt Noonan, Tessa Vande Griek,
 Eliane Barrett, Kevin Pomeroy, and Peter Curtis)

Distribution: University Press of New England, Hanover, New Hampshire

ISBN: 0-9705511-2-6

Thistle Hill Publications is a Vermont publishing company
that specializes in art and photography books and works
about and of interest to the people of northern New England.
Its address is Post Office Box 307, North Pomfret, Vermont 05053.

GREEN MOUNTAIN NATIONAL FOREST,
BIG BRANCH WILDERNESS

*McGinn Brook cascades
down rugged slopes through
verdant summer woods.*

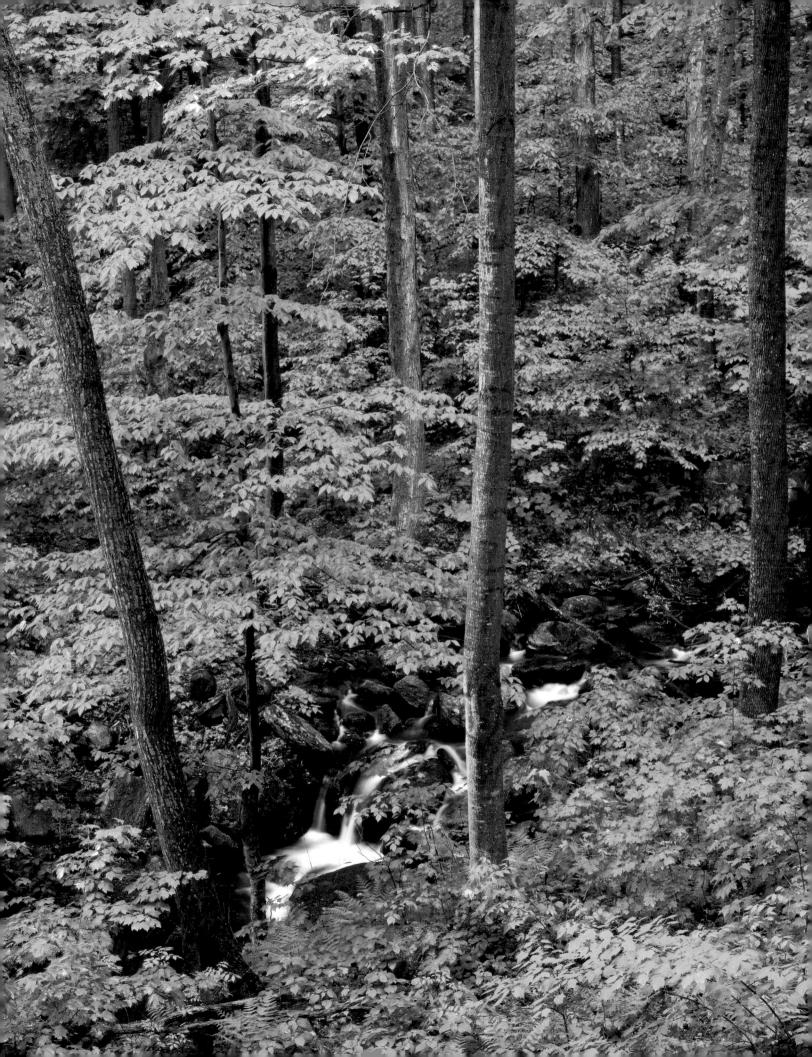

GREEN MOUNTAIN NATIONAL FOREST, LYE BROOK WILDERNESS

Lye Brook Wilderness retains clear evidence of past logging. But where slopes were once clear-cut and streams were choked with runoff debris, a remarkable transformation has taken place. Once again, a wilderness hiker can experience heavily forested valleys, streams that run clear, and—a rarity in our noisy world—peace and quiet.

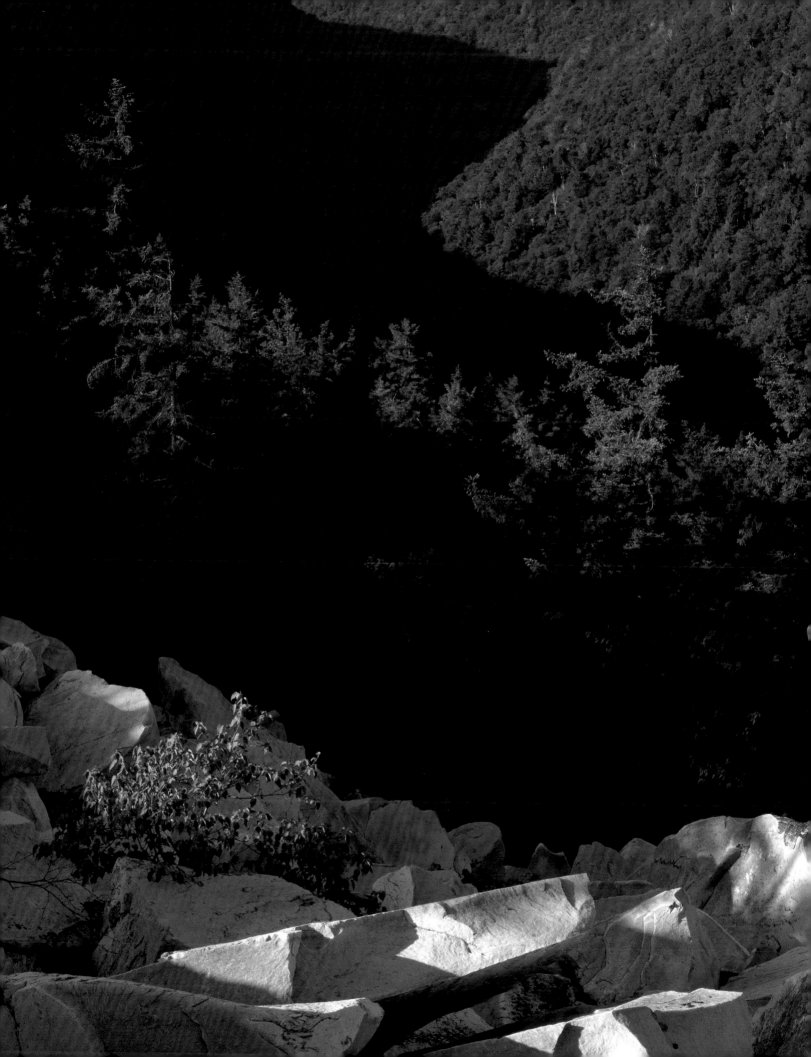

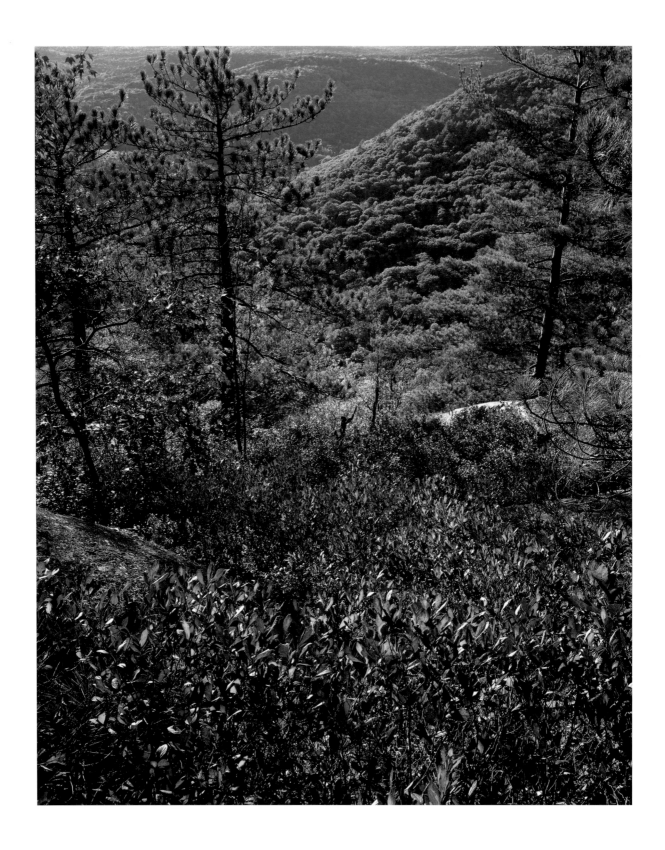

NATURE CONSERVANCY, CAVES SOUTH OF WOODWARD

*In these moist woodlands,
half-buried limestone boulders
lie scattered about like toppled
Mayan sculptures, many
of them crowned with
luxuriant green toupees
of wild ginger and trillium.*

BLACK MOUNTAIN NATURAL AREA, NATURE CONSERVANCY

*The granite summit ledges
of Black Mountain overlook
the West River valley,
known to Native Americans
as "Wantastiquet," or
"waters of the lonely way."*

GREEN MOUNTAIN NATIONAL FOREST, TACONIC CREST TRAIL

*Closely following the border
between New York and
Vermont, this trail travels
mostly through forest,
where a visitor can often
spot blooming plants
and fallen blossoms.*

9

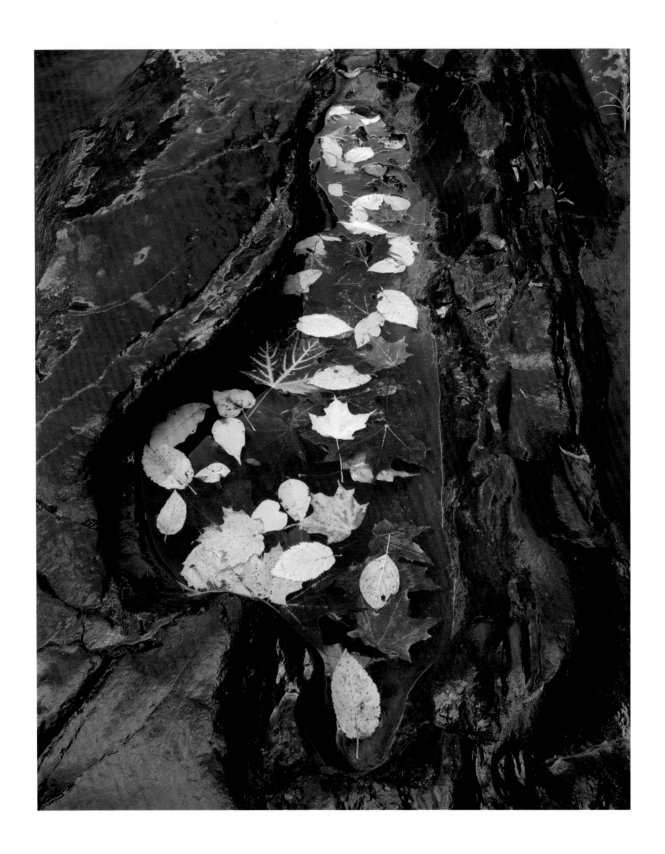

SHARING VERMONT

PATRICK LEAHY

Vermont has always been my home. My parents grew up in the hills of Vermont and they were wise enough to raise their family here, too. As a senator, I have been to remote places around the globe, and I have met people from every walk of life and from countries so different from one another it's hard to believe they are all on the same planet. But I have never been to a place so real and charming as Vermont.

Vermont is welcoming, it is peaceful, it is rural, and there are spots so remote they seem not to fit in such a populated country. It is not just Vermonters who appreciate its incredibly distinctive environment. Visitors to our state never forget their time here, and they return again and again. They revel in the inspiring colored leaves in autumn, the rivers and lakes that dot the countryside, and the countless hiking trails that weave

up and around the Green Mountains. The ski industry is a staple of our economy, but it is the reds, oranges and yellows of Vermont's maples that swell the state's population by the thousands for the short-lived fall season. Vermonters think our state is exceptional, and our visitors agree.

WILLOUGHBY FALLS WILDLIFE MANAGEMENT AREA

These falls, well known for springtime trout-spawning runs, tumble through dark gray rock pitted with potholes.

It is important to preserve Vermont's wilderness for our enjoyment and that of generations to come. Vermont's first-rate quality of life is partly due to the accessibility of open lands, mountains, lakes and rivers. Being surrounded by nature offers a time for solitude and reflection, recreation, and quality moments with loved ones.

The Green Mountain National Forest, spreading along the spine of Vermont, offers surroundings free of human influence and places for outdoor recreation. Maintaining and protecting the National Forest as well as other designated land becomes even more important as our population grows and open, undeveloped land becomes more scarce.

Untamed Vermont presents photographs that capture glimpses of some of our state's valuable natural beauty. As an amateur photographer, I am familiar with the difficult task of trying to capture what you see in person in a picture. Here, Blake Gardner's inspiring photographs are paired with knowledgeable comments by Tom Wessels that allow the reader to get the most out of the images. Blake's presentation of nature through his camera's lens is the way it was meant to be seen. His genius allows Vermont to be shared everywhere.

Patrick Leahy has been a U.S. Senator from Vermont since 1974.

GREEN MOUNTAIN NATIONAL FOREST
BREADLOAF WILDERNESS,
AUSTIN BROOK

Nature photography can be a spontaneous activity when conditions are right, but more often a location requires repeated visits in various seasons and different weather to get the scene just right. On this rainy autumn day, the elements all came together: the leaves were wet and shiny, and the brook, for once, was free of fallen trees.

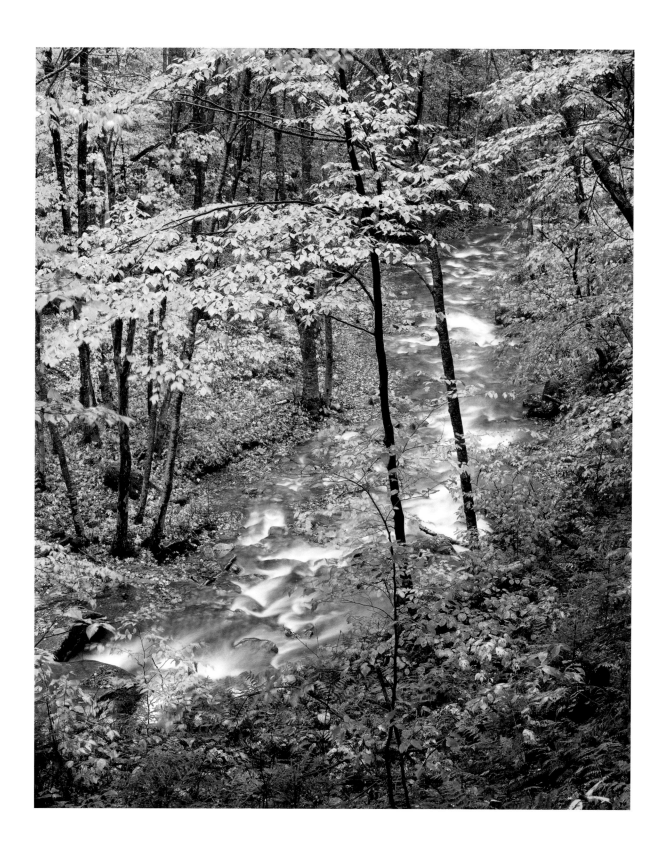

EMERALD LAKE STATE PARK

*Heralding spring's arrival,
the sun-loving shad is one
of the first northern forest
trees to flower.*

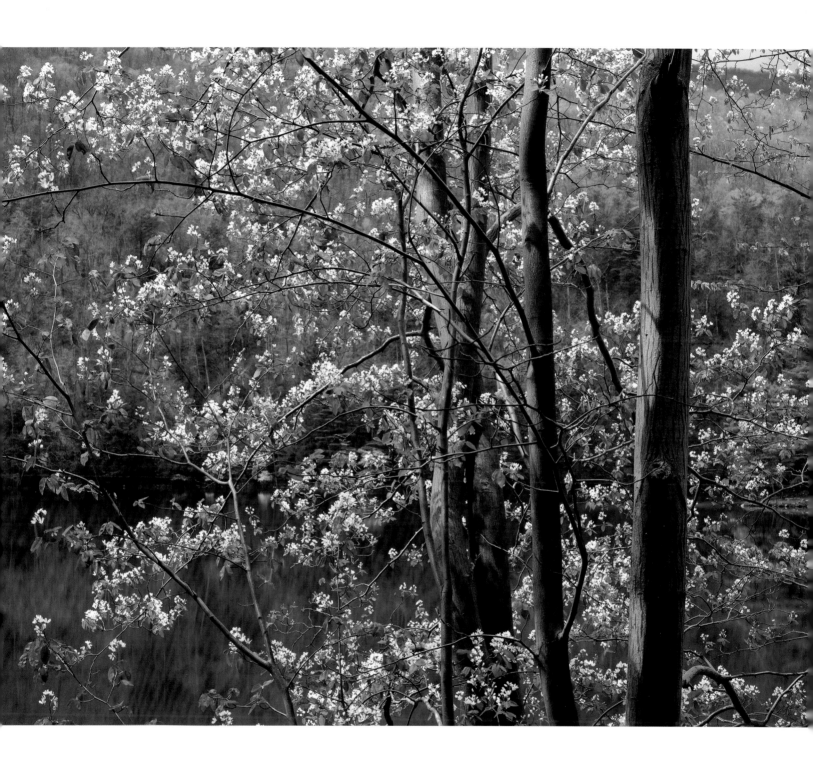

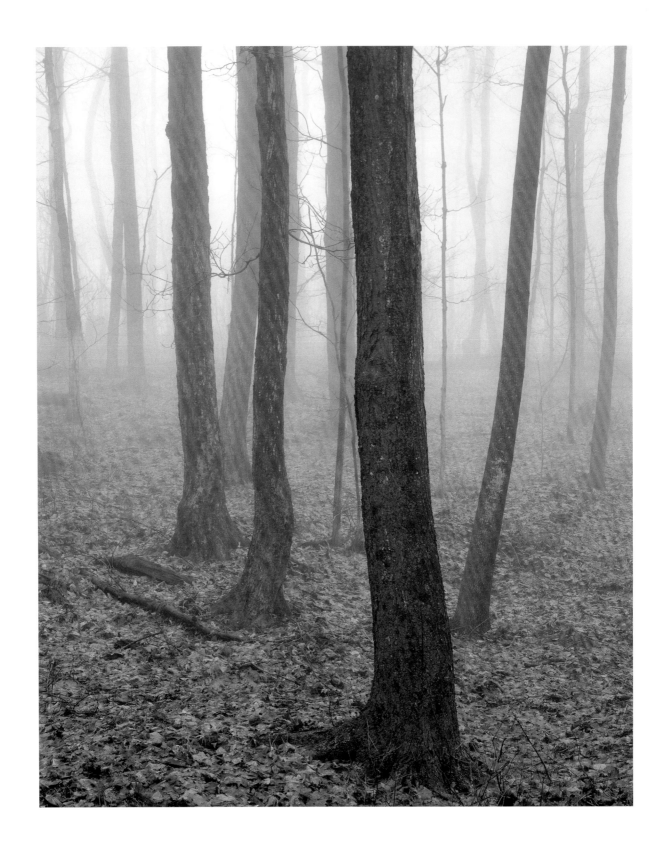

UNTAMED VERMONT – AN INTRODUCTION

JACK CROWL

Rolling green meadows with peacefully grazing cows. Brilliant, dazzling fall foliage. Quaint villages with white clapboard houses and tall church spires. Those are some of the images of Vermont that we all know, love, and have come to expect in any volume about the Green Mountain State. And every season, several new books depicting some variant of those images appear on bookstore shelves.

But there's another aspect of Vermont's beauty, one that's virtually unknown to many of us, except backpackers and nature lovers with a keen eye for detail. Off the beaten track — in hidden valleys, on desolate mountaintops, or often down that dirt road you just passed — are untamed and nearly secret wild areas with an incredible variety of landscapes, soils, trees, and wildflowers. In fact, for its size, Vermont's huge range of microclimates is unrivaled by any other state.

Pockets of such wildness can be found all over the state. Some are protected permanently, but many are not. Some have been designated "wilderness areas" by the federal government; others are unofficial, merely wild places on which man has made little mark. Some are difficult to reach, even on foot; others are just a short stroll from a roadside.

I'm sure that every state and region has its hidden-away private locations, places known only to old-timers, natives, and adventure seekers. Here in Vermont, we find that our wild areas are not only tucked away in remote sites that many of us will never see in person, but are also among our state's most beautiful and photogenic places.

Fortunately, more than a decade ago, expert nature photographer A. Blake Gardner began chronicling Vermont's wilderness areas for us. With his large-format camera tucked into a specially-adapted backpack, Gardner has tromped the backwoods for years, often climbing mountains in the dark of night to be able to photograph the first rays of sun to hit their peaks, or waiting for hours—or days—for the just-right light to flood wildflower-filled valleys or long-distance views. He has already produced one beautiful book of such photos, *Vermont Wilds* (Storey Publications, 1991), which is now out of print.

In the years since then, Gardner has continued to trek to more of our wild areas and to photograph them, carefully and lovingly and patiently. They depict wild areas throughout the state in all seasons of the year, all kinds of weather, and all shades of color and light. We present them to you in these pages for your perusal and appreciation.

For this volume, Tom Wessels has written an explanatory text to supplement Gardner's exquisite photographs and to put the scenes they illustrate into perspective. Wessels, who was the founding director of the Conservation Biology Program at Antioch New England Graduate School and is the author of *Reading the Forested Landscape* (Countryman Press, 1997)

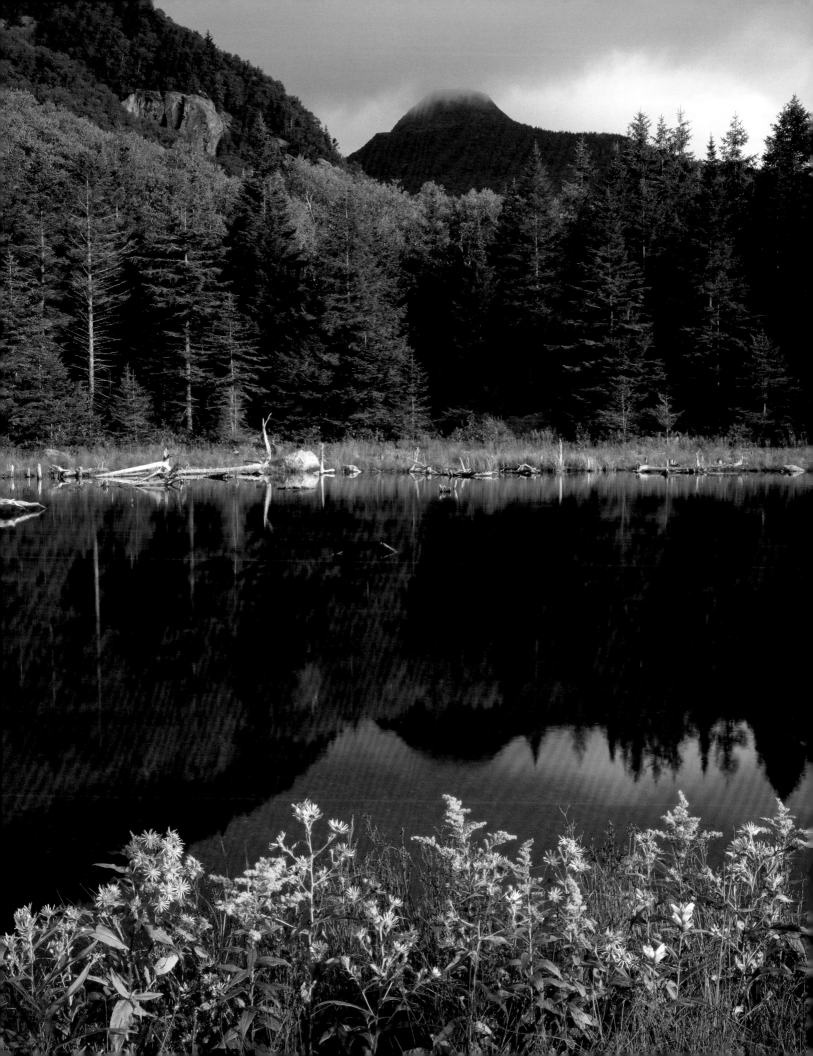

and the award-winning *The Granite Landscape* (Countryman Press, 2001), describes the incredible natural diversity of Vermont ecosystems and explains why and how they came to be.

It is not possible, because of vast changes wrought by man, nature, and time, to truly experience what our forests and fields were like in the days before the coming of European settlers. But the wilderness areas that do now exist are just about as close an approximation as we can have. Wessels explains Vermont's ecological diversity by examining the state's geology, its history, and its culture. And he scrutinizes the present threats to that diversity and makes recommendations for its preservation and stewardship.

We invite you to join us in these pages to discover a distinctly different, yet ruggedly familiar Vermont. Tour the state's backcountry vicariously with Blake Gardner's photographs, and read Tom Wessels's essay to make sense of it all. *Untamed Vermont* is, we think, an attractive book and a fine coffee-table volume that will quickly become a collectors' item. But even more, we hope it will serve as a reminder of how fragile the natural beauty of the wild and untamed parts of our beloved state is, and how vital to our well-being its preservation is.

Finally, the publisher would like to thank the numerous people and organizations who have offered encouragement and suggestions to us as we put this book together. We especially want to thank the Vermont Natural Resources Council for its steadfast support, both moral and financial, for this project. And we would also like to thank Senator Patrick Leahy for endorsing this book, as well as for inspiring it.

Jack Crowl is the president of Thistle Hill Publications.

GREEN MOUNTAIN NATIONAL FOREST,
BIG BRANCH WILDERNESS

Dripping with water, succulent wild grapes are a favorite food of many migrating birds. In winter, the dried fruit supports animals when nourishment is extremely scarce.

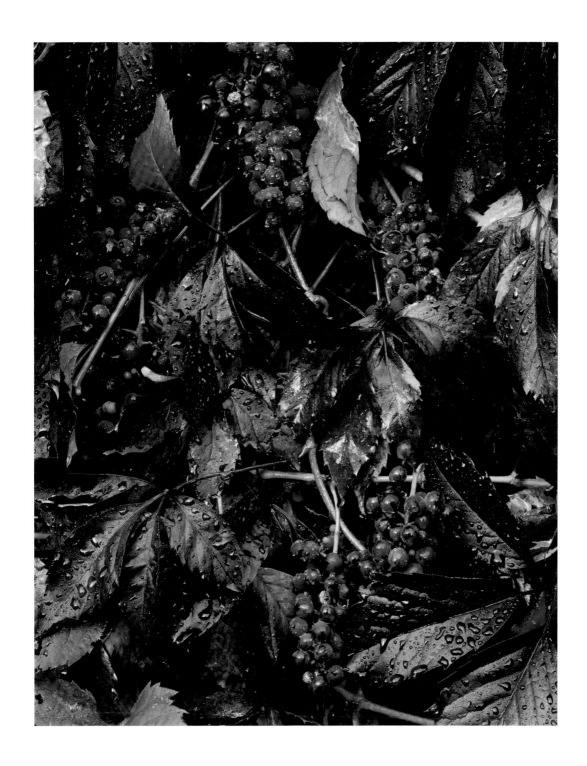

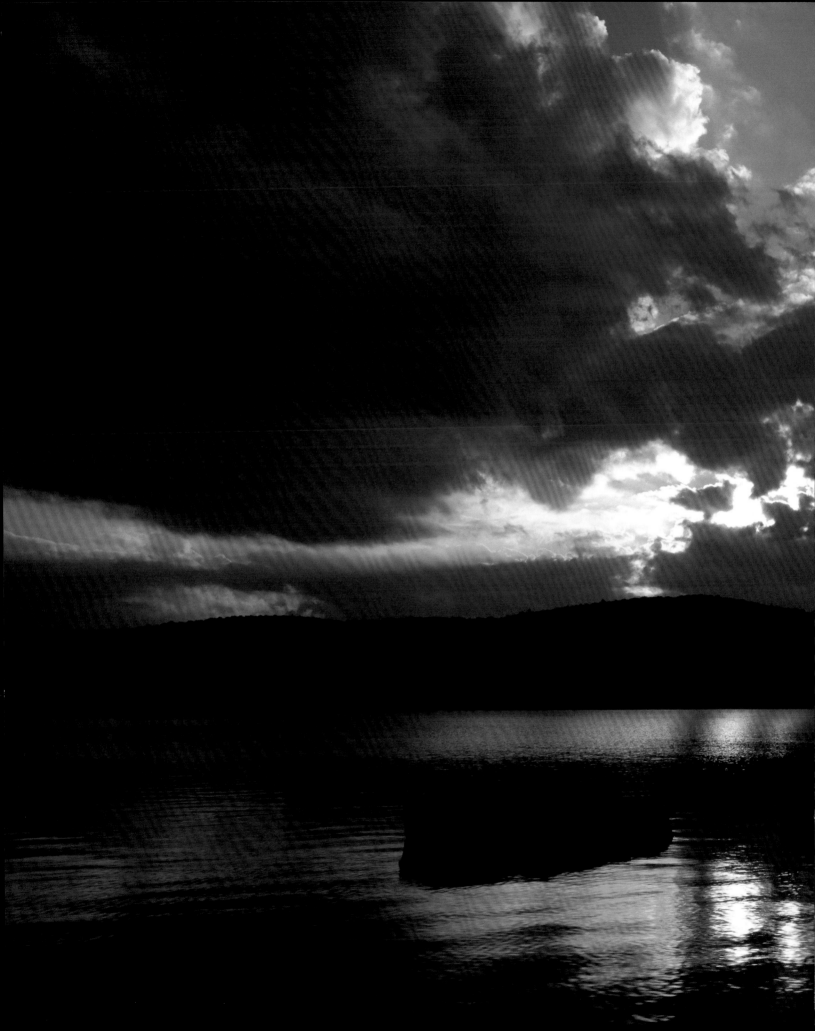

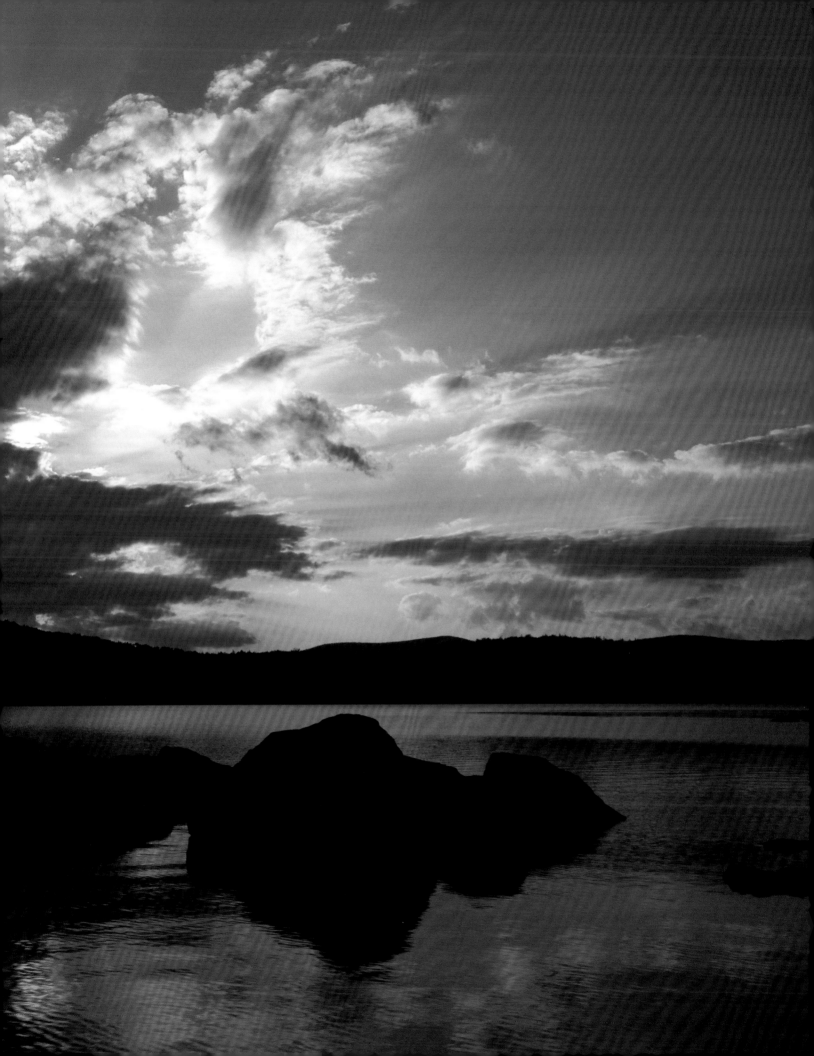

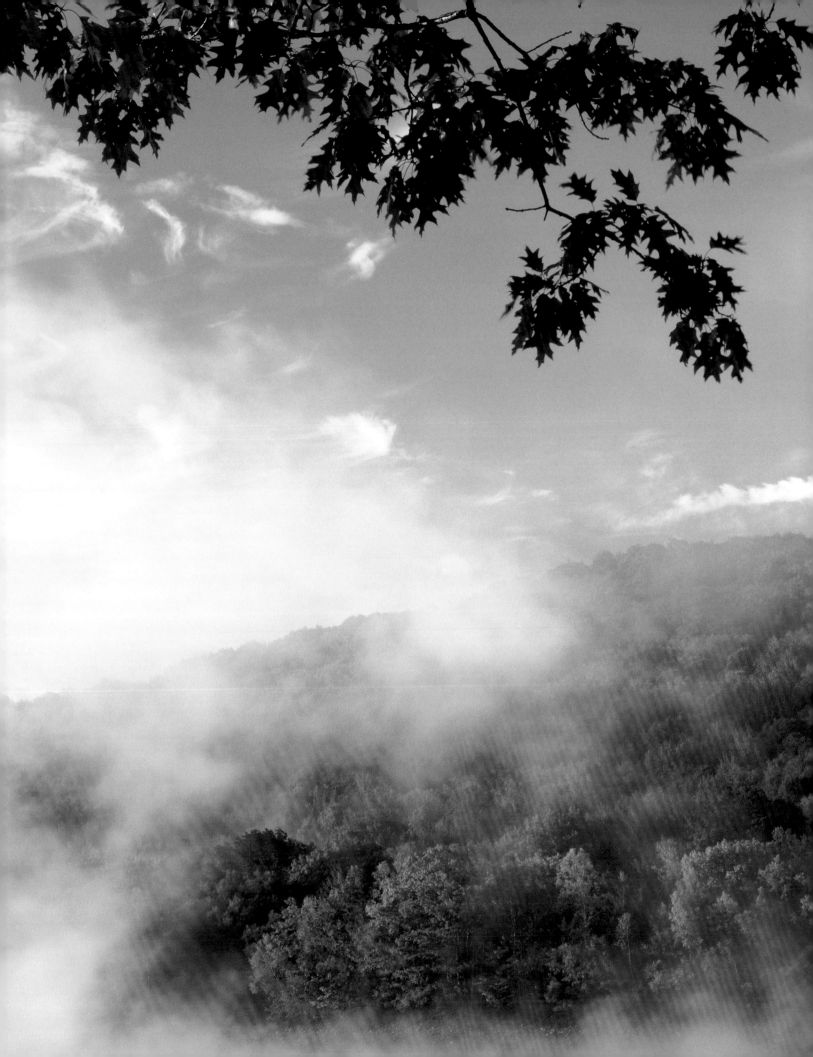

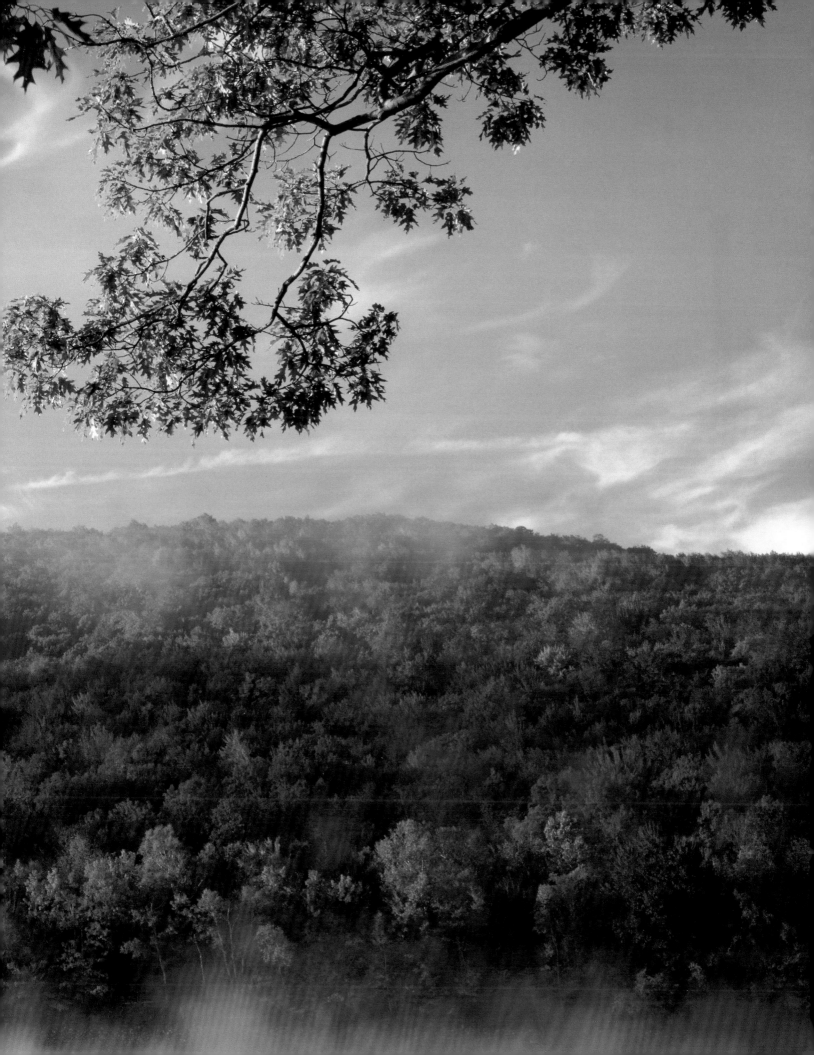

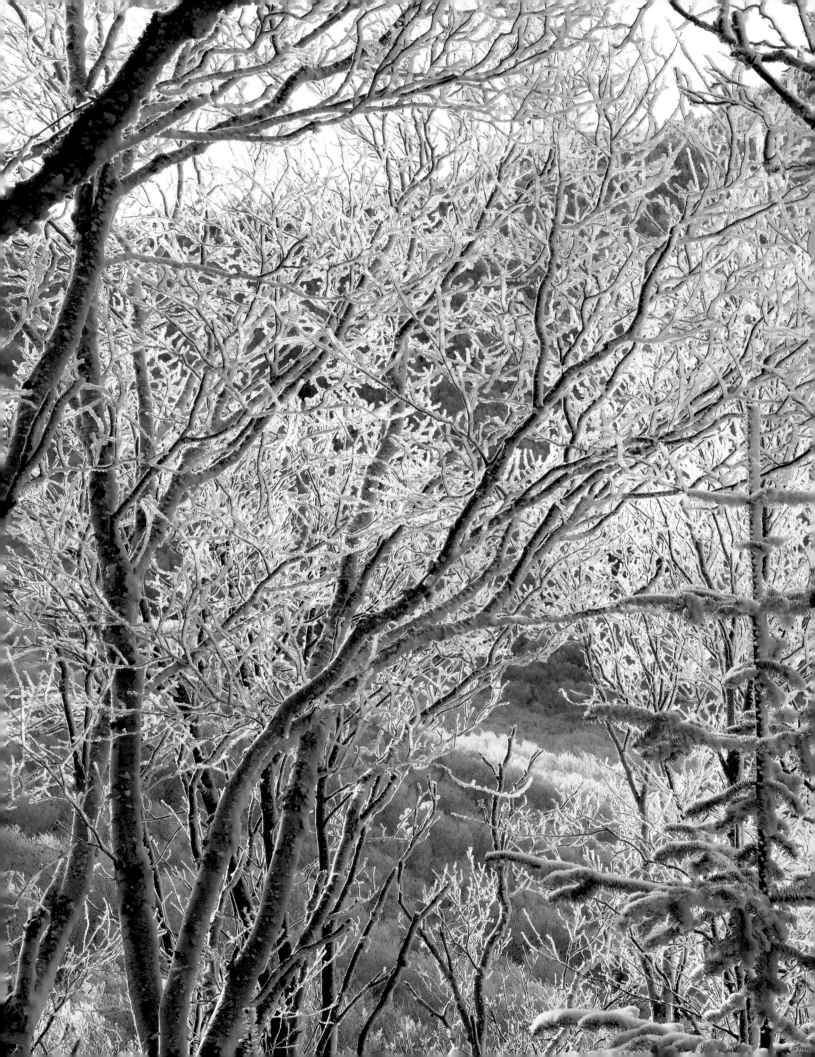

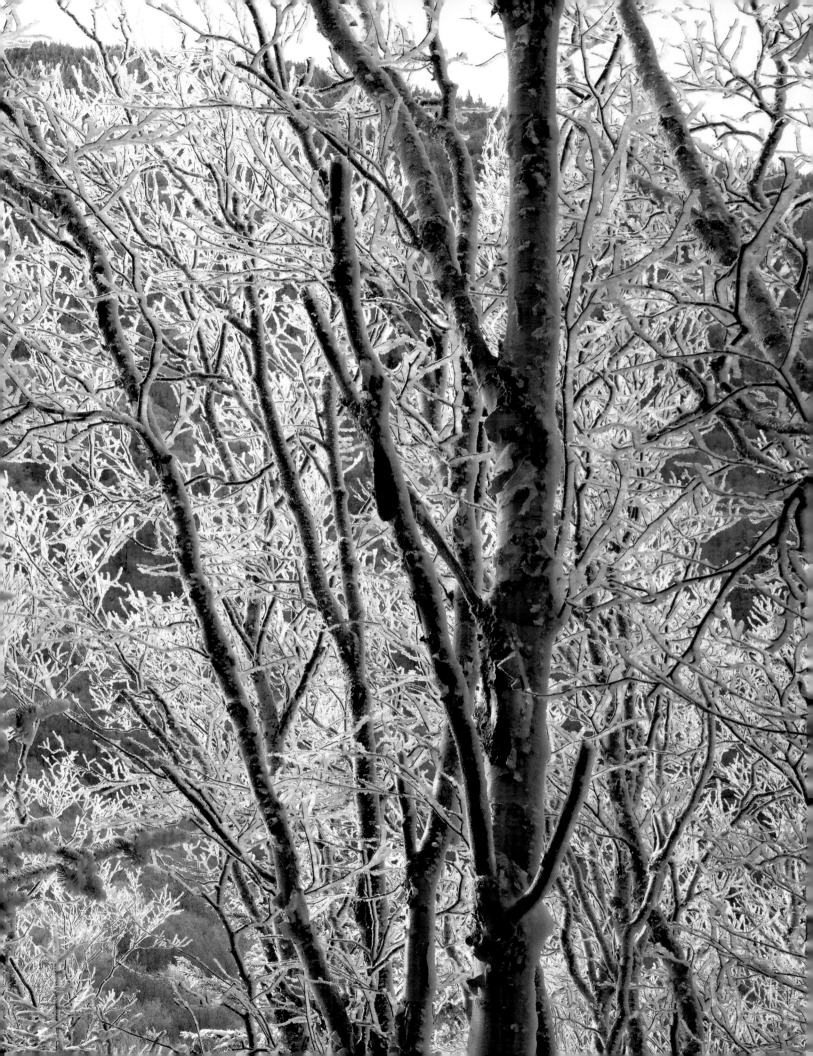

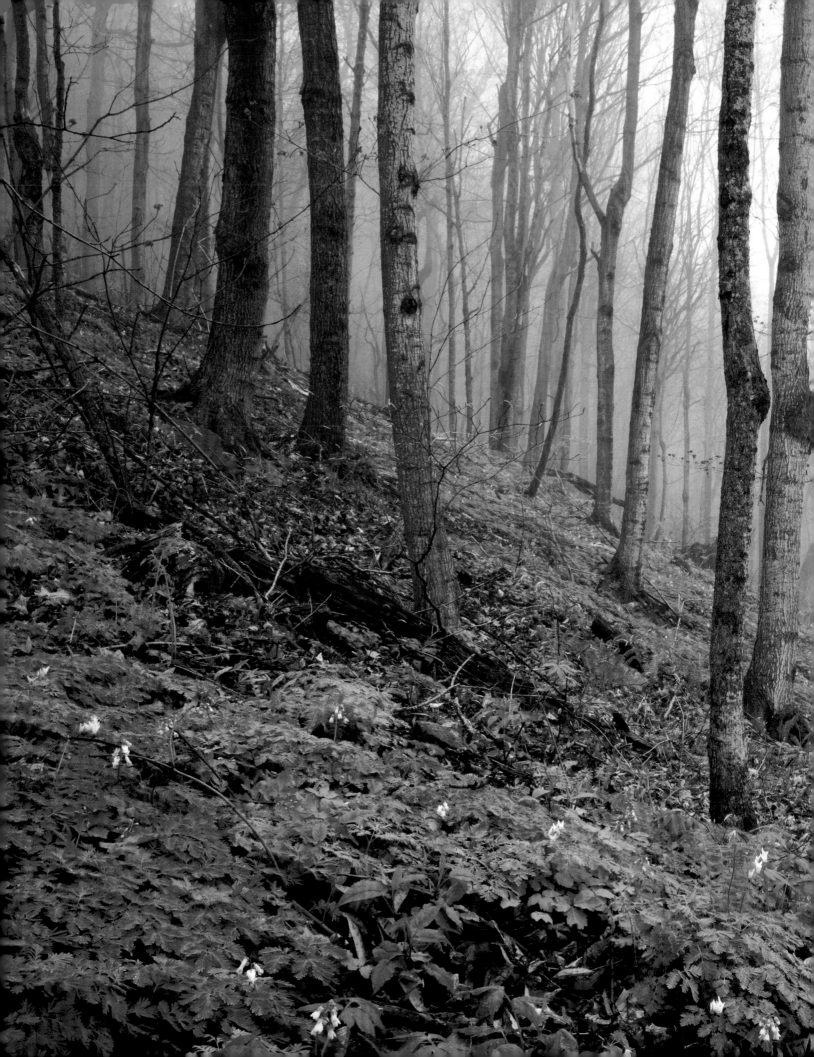

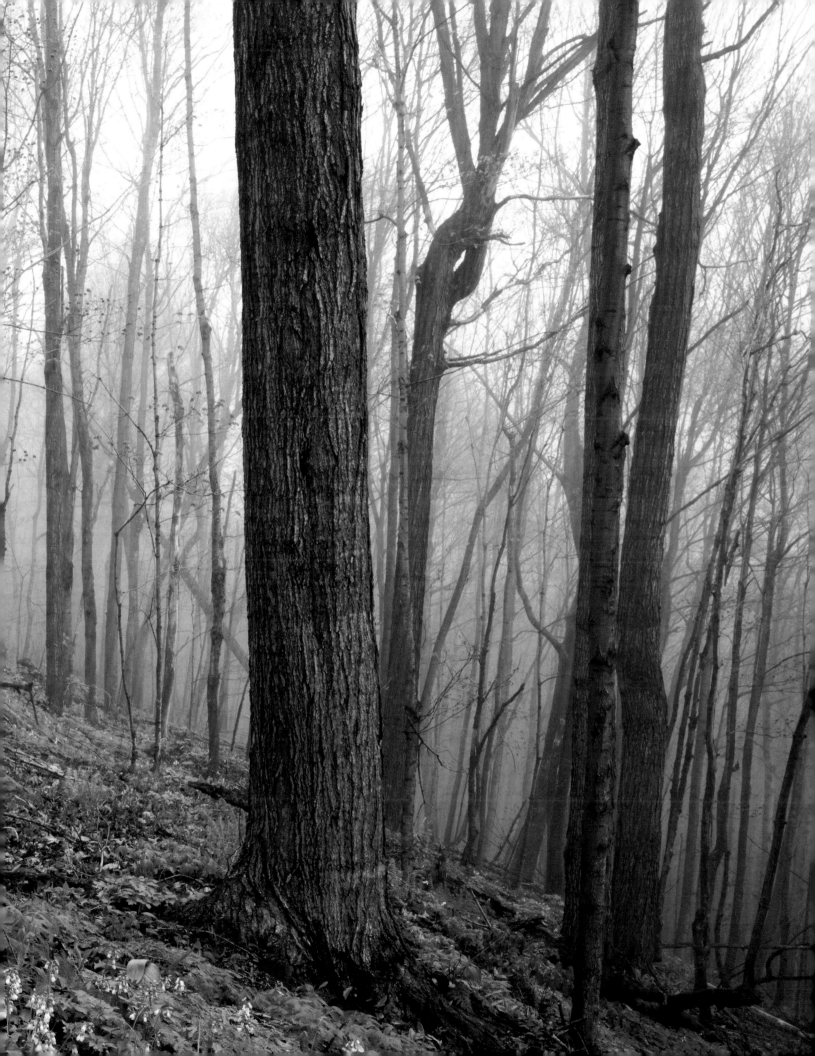

SOMERSET RESERVOIR ➤

A ten-mile-long dirt road leads to this undeveloped reservoir, which seems almost like a remote Canadian lake. A visitor can often spot common loons. Somerset feels truly wild when that diving bird's haunting calls echo eerily across the water.

CAMEL'S HUMP STATE FOREST, LONG TRAIL ➤

Rime ice collects delicately on tree limbs high in Camel's Hump State Forest. A few hundred feet farther down the mountain, heavy ice from a notorious 1998 storm devastated an entire zone, leaving trees broken and bent.

≺ HARRIMAN RESERVOIR

Harriman Reservoir, the largest in Vermont, is known for its Ledges, a bucolic but controversial area of natural rock benches where, despite much rancorous opposition, swimming and sunbathing are, by tradition, clothing-optional.

≺ MOUNT ANTHONY

Mount Anthony, in Vermont's southwest corner, has some excellent examples of a type of woodland known to foresters as rich northern hardwood forest. Dominated by sugar maples, the woods' dark, moist soils promote lush displays of spring wildflowers.

MOUNT ANTHONY

On hot spring mornings after a night of soaking rain, the woods feel like a greenhouse. The humidity is tangible and the air seems laden with rich earthy smell. Water trickles everywhere, and even the glistening purple trilliums seem to perspire.

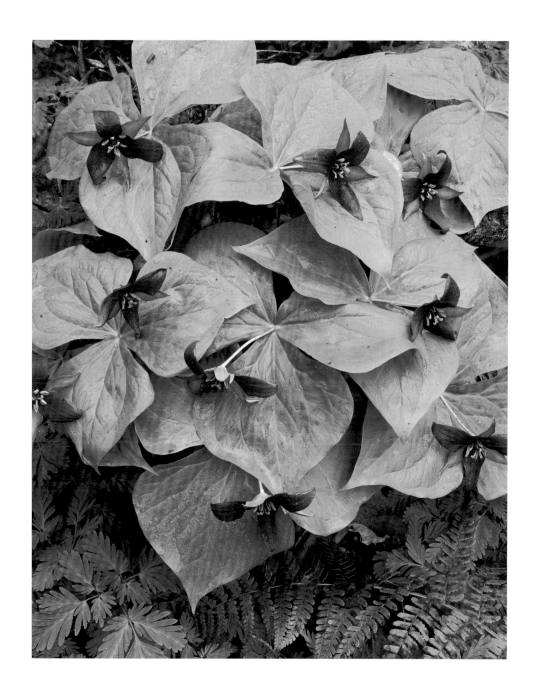

*Wings aflutter, a startled
warbler fled this ground nest,
which was photographed
quickly so the eggs wouldn't
cool. Afterward, the female
furtively scurried back to her
nest and stayed put, trusting
her eggs were safe.*

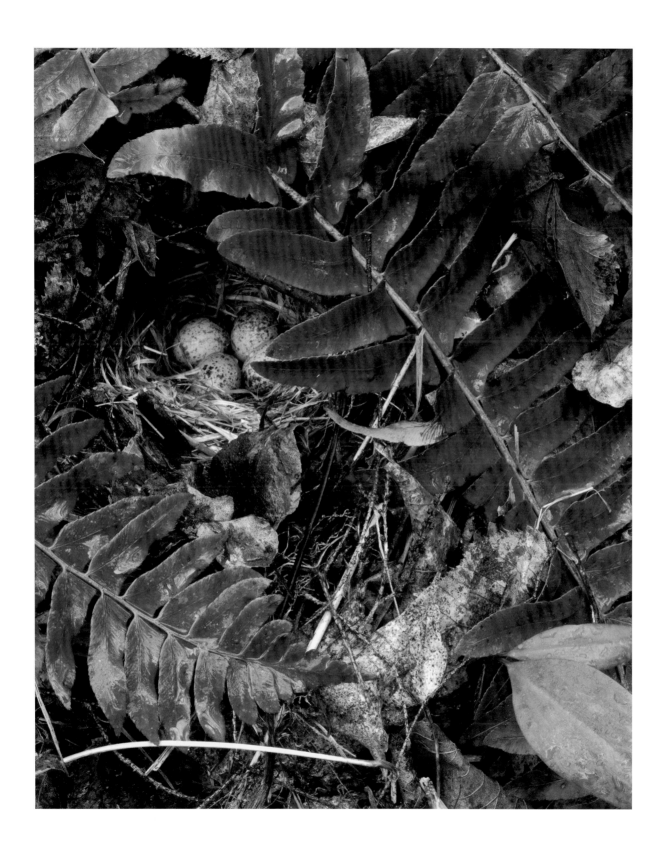

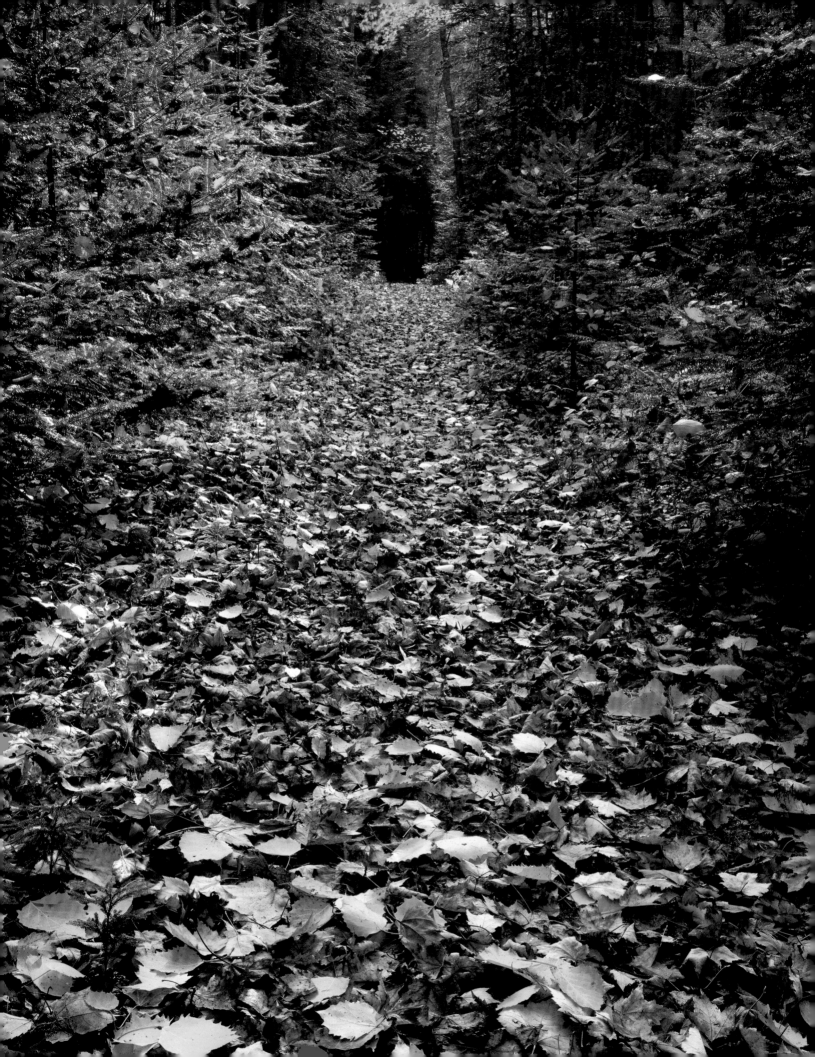

THE WILD PLACES:
WHERE THEY ARE,
AND WHY

TOM WESSELS

BRIGHTON STATE PARK

*This 152-acre park borders
Spectacle Pond, which,
according to Charles Johnson
in* The Nature of Vermont,
*was where the Iroquois
Five Nations built their
council fires and was
on the migration route
of the St. Francis Indians,
traveling from inland Canada
to the Atlantic coast.*

"Made in Vermont."

I've often wondered why that slogan has become such an effective marketing tool. Products touted as being made in Massachusetts, New Hampshire, or New York just aren't as attractive to consumers as their Vermont counterparts. Why not? My best guess is that Vermont products capture an old-fashioned, rural quality that is mirrored in its landscape. That image—so effectively portrayed in *Vermont Life* magazine for years— now seems to have been bestowed upon Vermont goods, endowing them with a patina of genuineness and purity.

But there is another important aspect of Vermont's landscape— the remote, wild, and untamed areas—that adds another facet to the state's image: unspoiled. Now, in this compelling portfolio, the skilled eye of Blake Gardner captures the essence of those locales. When Blake first approached me to collaborate with him on this project, what most

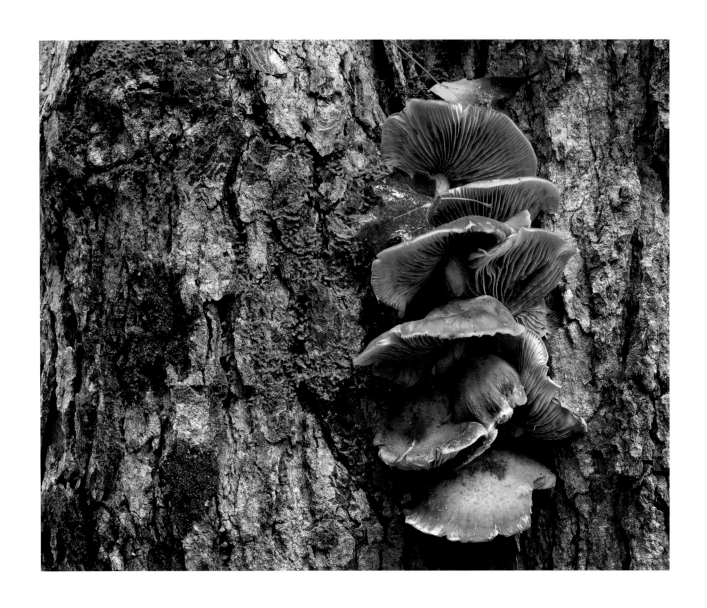

struck me about his work was the wide array of landscapes and natural communities that he managed to document in just a few dozen photos—a testament to Vermont's natural diversity. In their wonderful book, *Wetland, Woodland, Wildland*, Liz Thompson and Eric Sorenson describe eighty-two distinct upland and wetland communities in Vermont. That number doesn't even include those in ponds, lakes, rivers, and streams. At similar latitudes in the Midwest, states like Iowa, Nebraska, Minnesota, and the Dakotas—all six to eight times the size of Vermont—host far fewer natural communities.

How is it that such a small state, ranking forty-fifth in size, has such an assortment of ecosystems? To understand why Vermont's untamed landscape is so diverse, we need to go back in history more than 500 million years. At the beginning of the Cambrian period, 570 million years ago, the ancestral continent of North America was tipped on its side. What is now the eastern seaboard of the United States was facing the South Pole at a latitude of about twenty-five degrees south of the equator. The bedrock we can now stand upon (on summits such as Camel's Hump), or see veiled by the state's numerous waterfalls, was then

accumulating as oceanic sediments in a subtropical sea. For tens of millions of years these sediments accumulated to great depths at rates sometimes as slow as a millimeter every ten years. Then by the middle of the Cambrian era, when oceanic life was undergoing a dramatic evolutionary surge, the skeletal remains of many of these invertebrates began to pile up on top of the previously deposited sediments, eventually creating a carbonate platform thousands of feet thick.

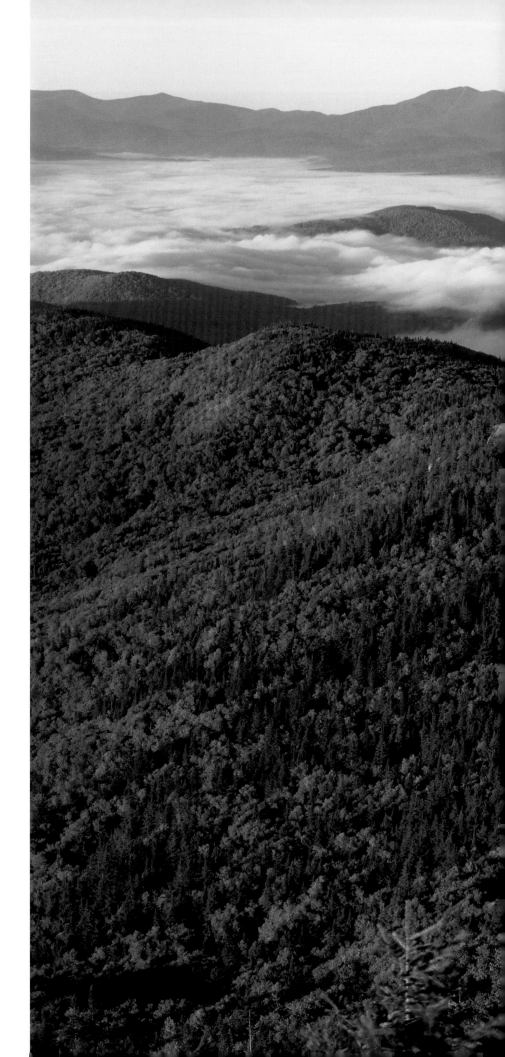

PUTNAM STATE FOREST

One of the peaks in the small
Worcester Mountain Range,
Mount Hunger's summit
provides an unobstructed view
of a valley hidden in fog.

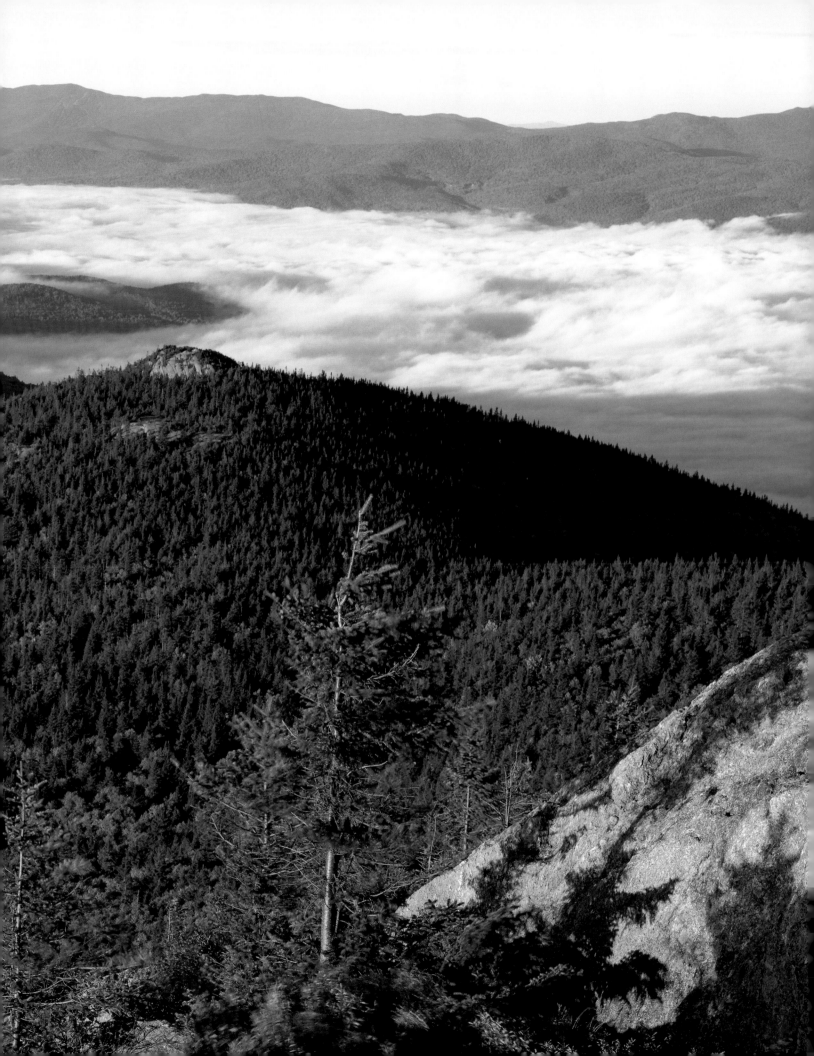

By the end of the Cambrian period, 500 million years ago, the globe's continents started to pull together—eventually to form Pangea, the super-continent that subsequently broke apart into the continents that we know today. The converging of the ancient continents compressed, folded, and lifted the Cambrian sediments and their carbonate platform to create the original Taconic Mountain chain, a vaulted range that 470 million years ago probably looked much like the Andes of South America. To visualize this mountain-building process, take a number of different colored blankets (representing various sediment layers) and lay them out flat on a floor, one atop another. Then place a thick quilt (the carbonate platform) on top of them. Now, with a partner, push in on the stack from two opposing sides and watch the layers fold as a growing mountain range develops. The folded bedrock that millions of years ago lay miles deep within the heart of the ancient Taconic Range is today a primary reason for our state's natural diversity.

Seen from the air, Vermont is largely composed of numerous north/south-running ridges separated by valleys. The ridges are composed of relatively hard erosion-resistant bedrock, while the valleys are underlain by erosion-prone and often calcium-rich bedrock. Taking any east/west route across the state, a hiker will encounter an ever-changing array of natural communities as she climbs and descends ridge after ridge. With each ascent and descent she will cross many different surfaces, derived from different strata in the bedrock, and numerous topographies, each creating changes in solar gain, temperature, moisture, and wind exposure. This complex of differing soils and topographic sites, derived from the underlying geology, gives rise to what ecologists call a high level of

GROTON STATE FOREST, LORD'S HILL NATURAL AREA

Most people don't realize that much of Vermont's woodland was once cut down or burned for charcoal production, logging, or sheep farming. Few virgin stands remain, but Lord's Hill Natural Area somehow escaped intensive logging. Labeled with tags like museum specimens, the old trees are examples of what was almost lost.

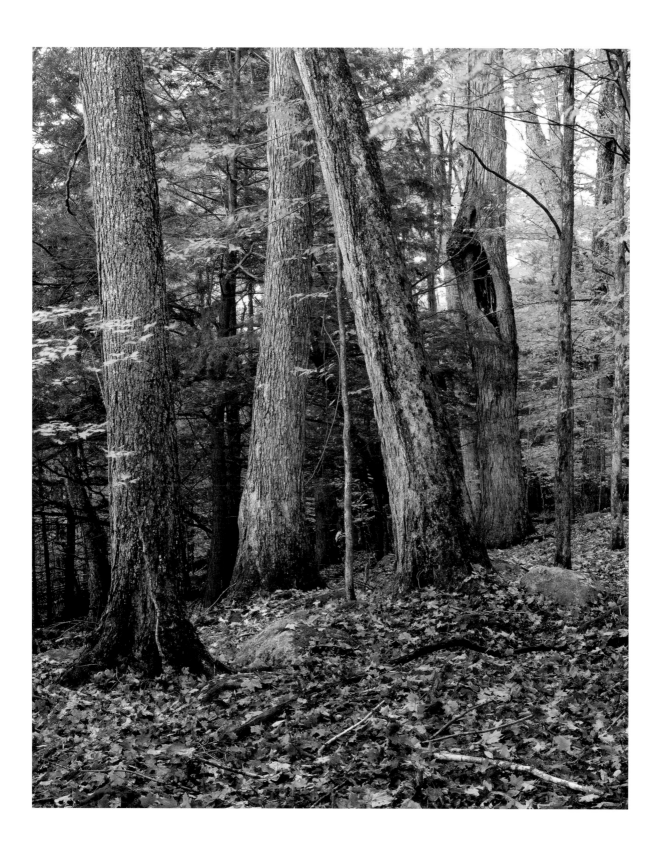

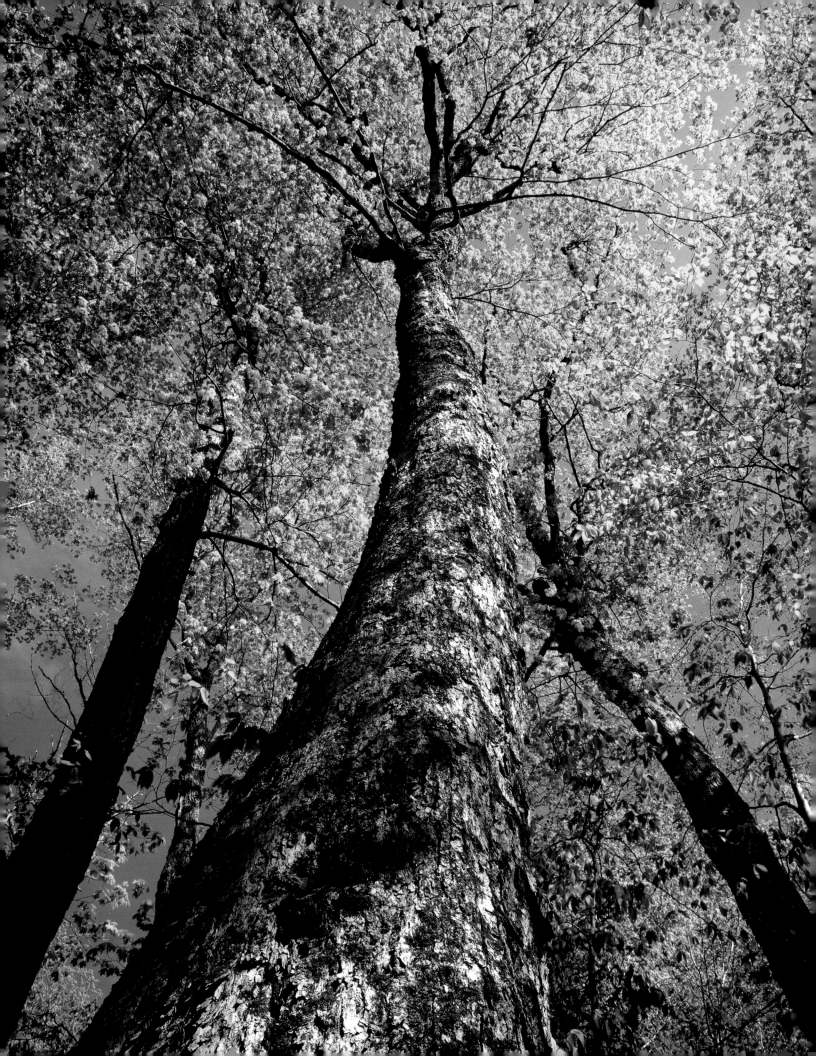

physical structure. Areas that have a lot of such structure have greater biotic diversity because a wide variety of different species can thrive in the numerous microenvironments created there. This is the main reason Vermont hosts more natural communities than large, relatively flat, Midwestern states. In addition to the ancient bedrock, recent (geologically speaking) glacial deposits blanket the Vermont countryside. Those sands and clays of various composition create a whole new array of surfaces on which varied plant life can grow.

GIFFORD WOODS NATURAL AREA

This National Natural Landmark preserves a small ancient stand of maples that may have been sugared sometime in the last 400 years. With many decaying logs, old-growth trees, and an extensive ground cover of ferns growing from the rich dark earth, these few acres offer a glimpse of what forests looked like before they were removed.

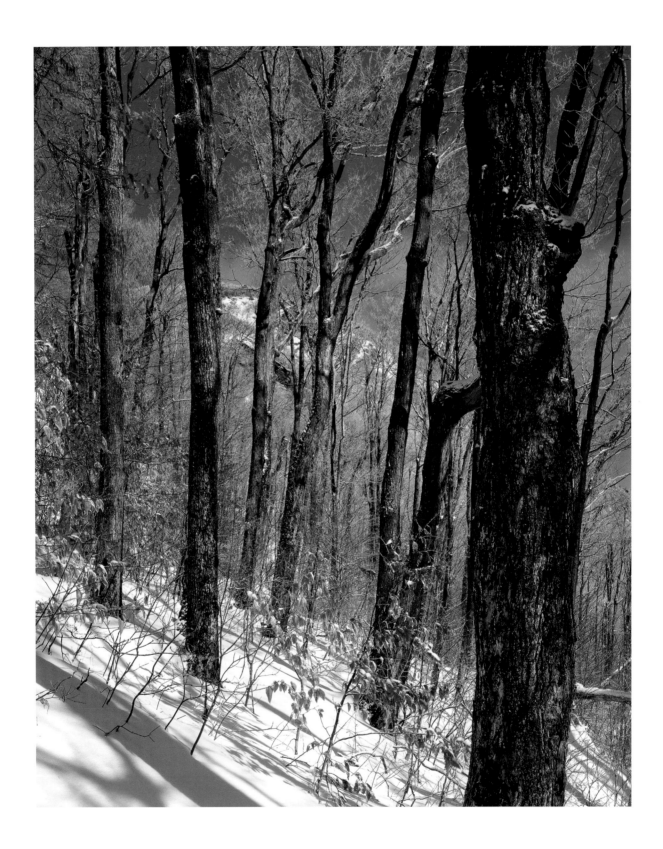

GREEN MOUNTAIN NATIONAL FOREST,
ROMANCE MOUNTAIN WILDERNESS
(PROPOSED)

*Lugging fifty-five pounds
of camera gear up a steep
trail covered with waist-deep
snowdrifts can be frustrating,
especially on a windy day
with the kind of dull light
that makes good picture-taking
difficult. Luckily, a distant
view of Mount Horrid
appeared when the clouds
broke temporarily.*

UNDER A MILE-DEEP GLACIER

About thirty thousand years ago, a lobe of the Laurentide Ice Sheet that then covered eastern Canada began to push its way into Vermont. It cloaked the state with a frozen sheet more than a mile thick, until it departed some thirteen thousand years ago. As it slowly flowed over Vermont, the glacier plucked rock, which was ground to fine sands, silts, and clays that eventually polished the remaining underlying bedrock. The quarrying was most pronounced in the valley bottoms, where glacial notches—often called gulfs in Vermont—were gouged. As the ice sheet wasted away, sands, silts, and clays were carried out of the glacier by the melting water and deposited in lakes that grew at the front of the receding ice.

When ice thousands of feet thick covers a landscape, its weight pushes that part of the continental crust down into the mantle—

a malleable portion of the Earth that underlies the crust. When the ice recedes, the removal of that enormous weight causes the continental crust to float back up in what is called isostatic rebounding. As the ice melted out of southern New England, the continental crust rebounded a few hundred feet and backed up watersheds to form pro-glacial lakes.

The sands washed out by the glacier were often deposited as deltas of rivers flowing into those lakes, while silts and clays, which stayed in suspension longer, slowly settled out on the lake floors. The two largest of the lakes were Lake Vermont, of which today's Lake Champlain is a

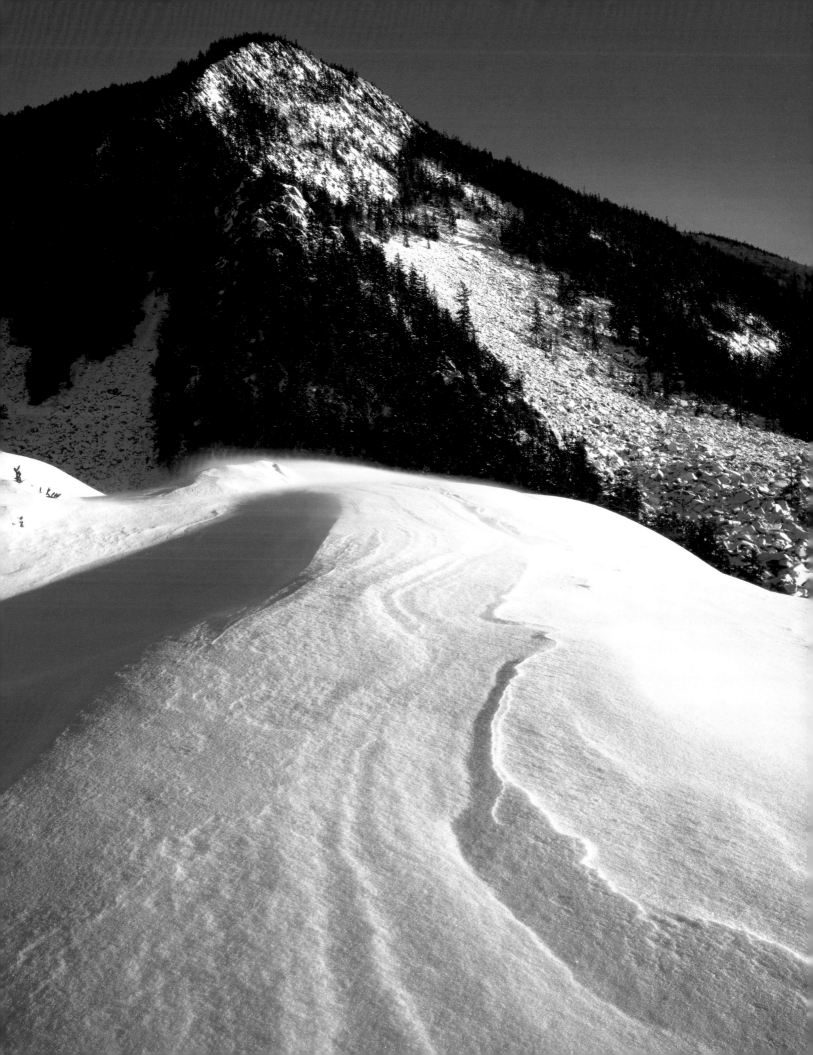

mere remnant, and Lake Hitchcock, which filled the Connecticut River valley from central Connecticut up toward the Canadian border. On the ridges above the valleys, a jumble of material called glacial till—boulders, rocks, sand, and clay—was directly deposited over the scoured bedrock. Where glacial ice quarried erosion-resistant ledge such as granite, it left a series of boulders trailing off to the south-southeast, the direction of the glacier's original flow. All of these glacial deposits add to the physical structure of the Vermont landscape.

Gouging basins in the bedrock and blocking drainages with deposits, the glaciers also created many of the state's wetlands. Huge chunks of ice cleaved off the front of the receding glacier were often buried in the sands deposited by glacial melt water. Upon melting, the ice chunks created kettle-shaped ponds that have since filled and been transformed into many of the bogs and swamps that grace the state. Most of the marshes we see today that are dominated by sedges, rushes, grasses, and reeds are of more recent origin, usually the result of the damming of streams by beaver or the filling of calm bays in lakes.

One of the more interesting features left by the draining of Lake Vermont is the clay that underlies some of the forests of the Champlain Basin. Here on this rich, moist soil we find southern oaks, shagbark hickory, sugar maple, and bur oak—a species common to the prairie states of the Midwest. Nowhere in New England except in this

basin and a few spots in the Housatonic Valley of Massachusetts does this unique forest community exist.

WEST MOUNTAIN WILDLIFE MANAGEMENT AREA

The simple beauty of leaves on Dennis Pond in autumn is a reminder that some places should be accessible but still remain wild.

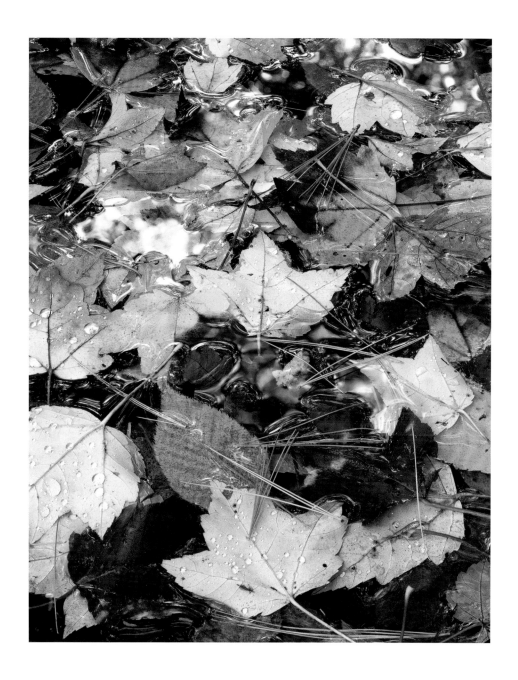

GREEN MOUNTAIN NATIONAL FOREST,
WHITE ROCKS RECREATION AREA,
BIG BRANCH RIVER

*Late fall is usually thought
to be drab and depressing,
but the first snows tend
to brighten the landscape
and renew the spirit.*

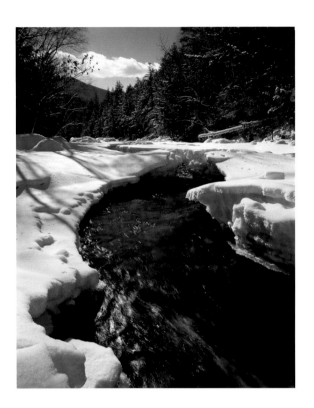

GREEN MOUNTAIN NATIONAL FOREST,
GEORGE D. AIKEN WILDERNESS

*Standing in a marshy meadow
behind an abandoned beaver
dam, cattails cast angular
shadows on fresh snow.*

GREEN MOUNTAIN NATIONAL FOREST,
GEORGE D. AIKEN WILDERNESS

*For an animal with short legs,
sliding across deep snow is
obviously easier than walking.
Confessing to a bit of
anthropomorphism, I believe,
after following a river otter's
curving slide trails, that
there is as much fun as
practicality in the animal's
chosen mode of travel.*

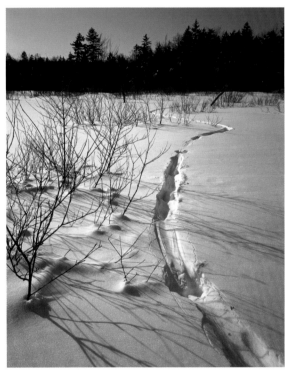

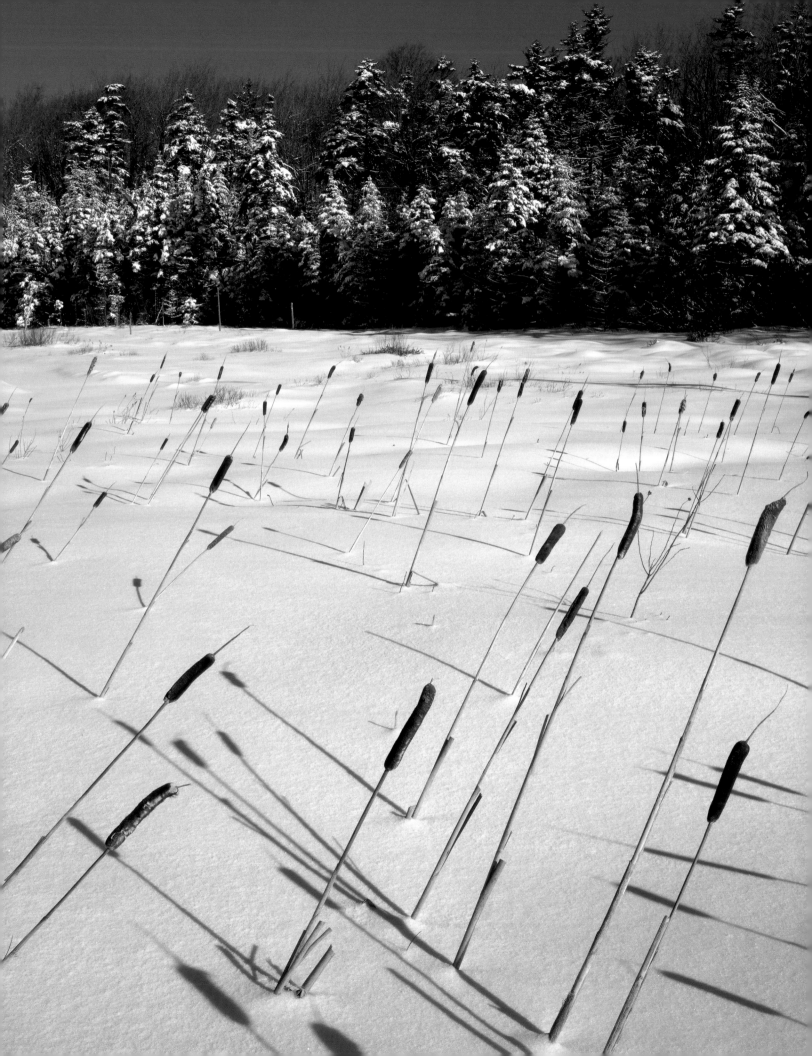

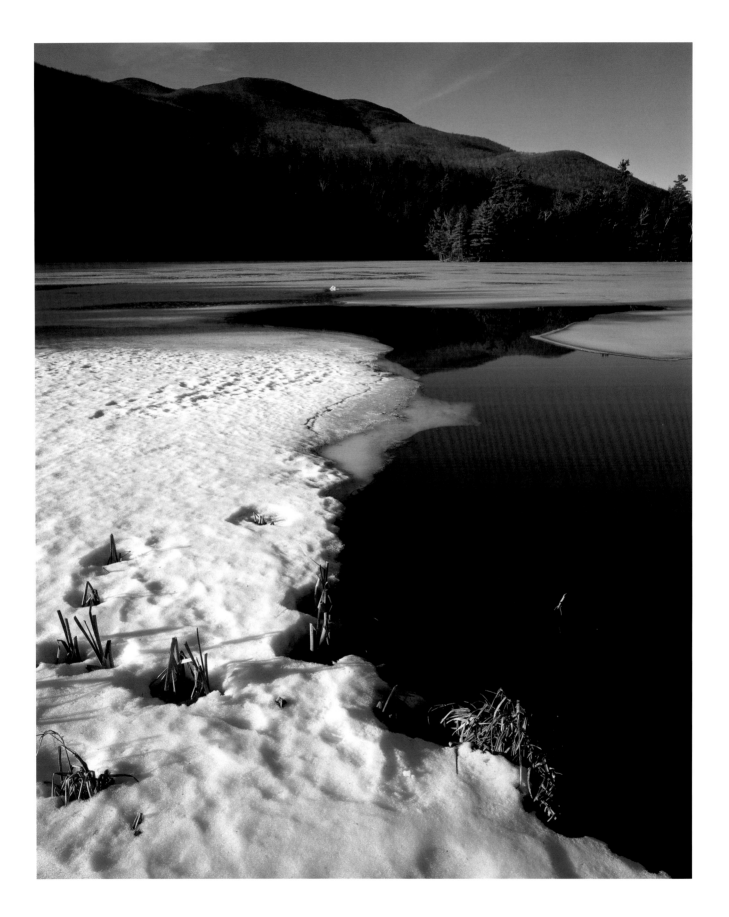

EMERALD LAKE STATE PARK,
DORSET PEAK

Located in the narrowest
section of what is often called
the "valley of Vermont,"
a thawing Emerald Lake
reflects the heavily wooded
flanks of Dorset Peak.

A TALE OF TWO FORESTS

To better visualize how physical structure fosters biodiversity, imagine two Vermont forests dominated by sugar maples. One developed after a hayfield was abandoned in the 1920's and is a stand of similar-sized seventy-five-year-old trees. The other is an old-growth stand with trees up to three hundred years in age growing out of a talus slope, which is a jumble of boulders that cleaved off from a cliff face and now lie at its base. Which forest will have the greater diversity? Because of its wide array of microenvironments, the talus slope can host many more species. The different exposed boulder faces and the numerous pockets and crevices create special physical conditions in which different species of plants can thrive. Spring wildflowers such as wild ginger, Dutchman's breeches, miterwort, and herb Robert abound in sites like this.

There would also be lots of old trees, some downed and decaying, each creating a variety of new microenvironments attracting many decomposing species of fungi and insects. In comparison, the seventy-five-year-old forest has much less physical structure and, as a result, far fewer species. The talus slope represents on a very small scale the nature of Vermont.

All the wildflowers mentioned above are plants that grow in calcium-rich soils. On her east/west route, as the underlying geology changes, our hiker will move in and out of rich-sited forests like the one on the talus slope. She won't do this just once or twice, but time and time again. In late April and early May, these rich-sited forests, dominated by sugar maple

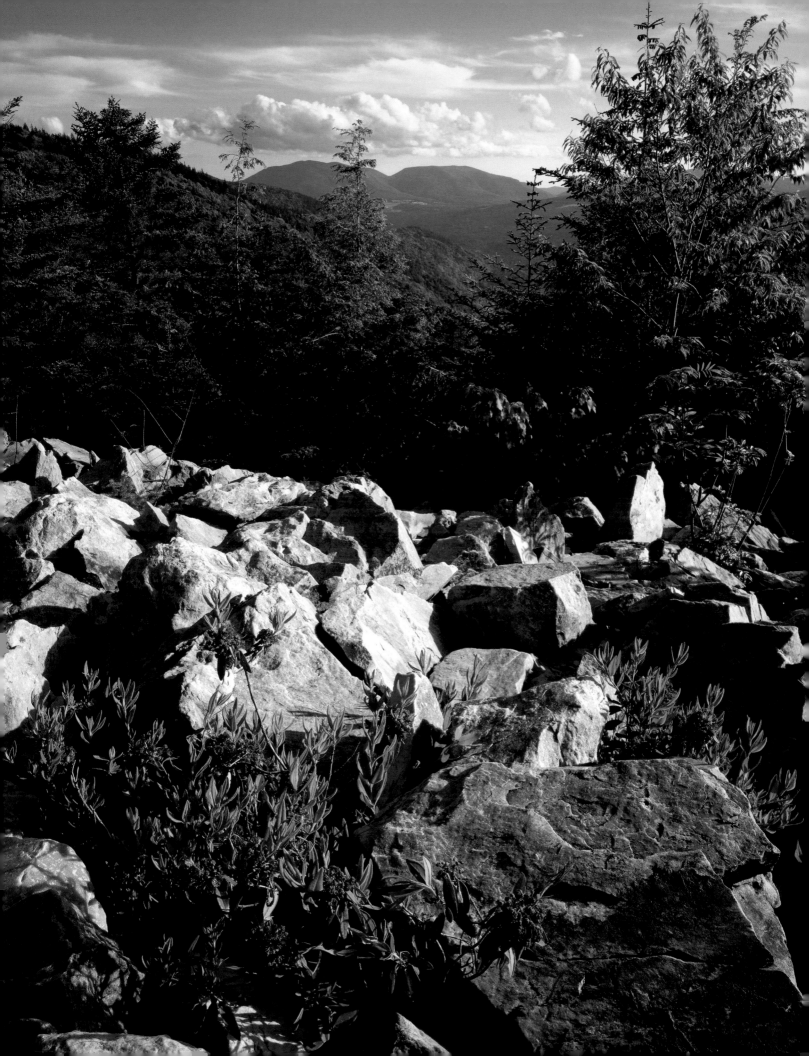

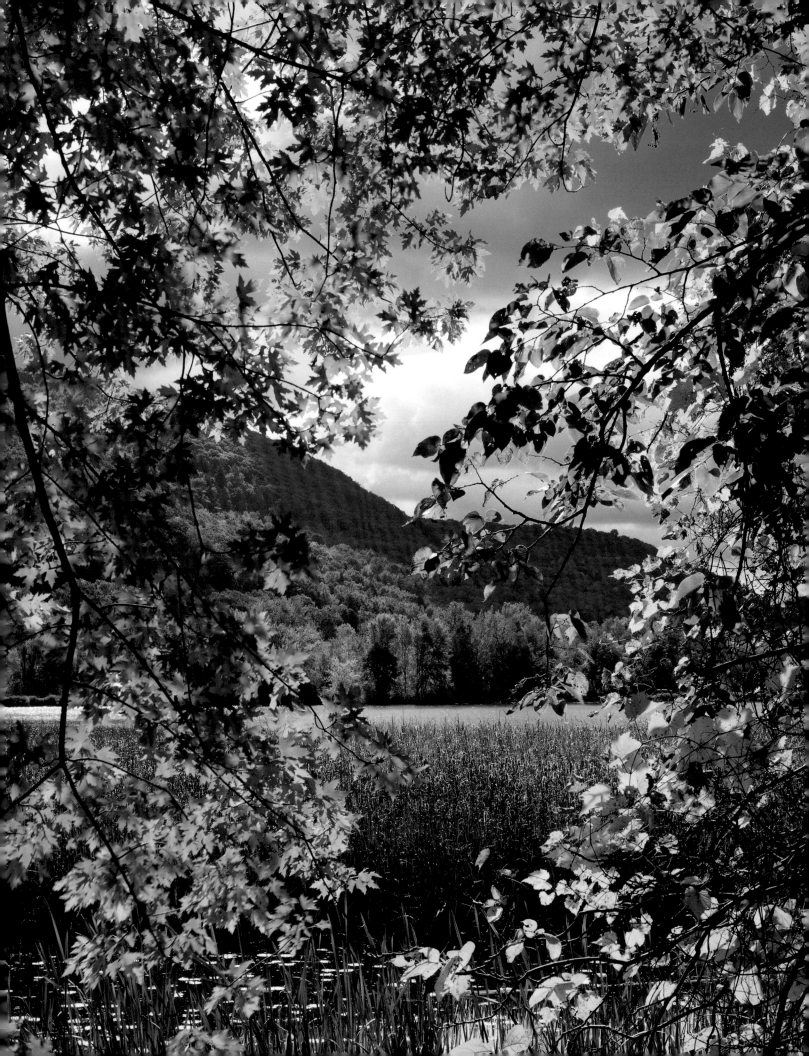

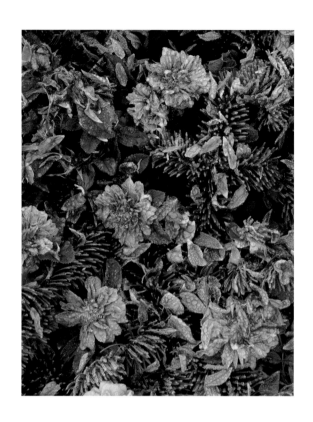

CONNECTICUT RIVER, HENDRICK'S COVE

The Connecticut River, New England's longest and largest, along with its tributary, the Williams River, has created a rich habitat of low islands and winding marshy channels. Bald eagles and osprey, rare most places, are rather common here. The many anglers and large numbers of well-fed belted kingfishers are proof of the excellent fishing.

VICTORY BASIN WILDLIFE MANAGEMENT AREA

After an early evening thunderstorm, wet swamp rose blossoms lie scattered among the dark foliage of balsam fir.

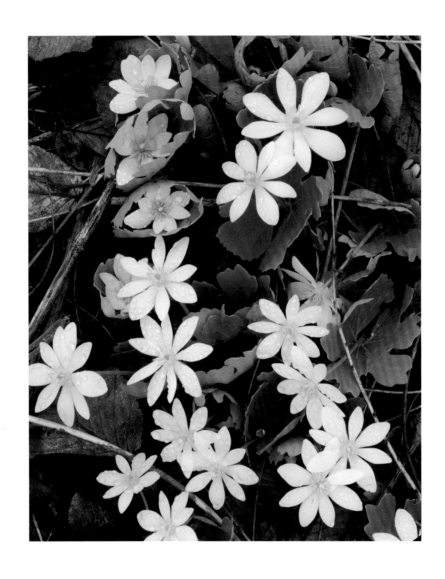

and white ash, host an association of Vermont's most exquisite woodland wildflowers. Along with wild ginger, Dutchman's breeches, miterwort, and herb Robert, she may encounter both red and white trillium, sharp-lobed hepatica, spring beauties, blue cohosh, trout lilies, toothwort, foam flower, and squirrel corn. Since many of these species bloom before bees are active, they rely on flies and moths for pollination. Wild ginger and red trillium both have malodorous flowers that in color are meant to resemble decaying flesh, to attract carrion beetles and carrion flies. The white to blue bowl-shaped flowers of the hepatica track the sun as it moves from east to west and, acting as warming posts on cool spring days, also attract carrion flies. White trillium, Dutchman's breeches, squirrel corn, toothwort, and foamflower have white blooms that stay open at night to attract moth pollinators. The delicate maidenhair fern, while not a wildflower, also grows in these same rich areas.

CONNECTICUT RIVER

Appearing before most spring flowers, the ephemeral bloodroot opens in bright daylight, a welcome contrast to winter's dingy leaves.

These forests look quite different by early summer. In late April, they are carpeted in deep emerald green—the first real flush of spring in Vermont. The lush greens are mostly from the leaves of wild leeks and Dutchman's 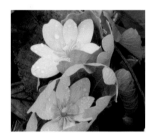 breeches. By June, the foliage of the leeks and Dutchman's breeches has withered into the soil, since both are "ephemerals" that do all of their annual photosynthesis before the sugar maples leaf out. In summer, the green of the forest understory is not quite as deep, composed mostly of blue cohosh and maidenhair fern. If you ever encounter a lush stand of cohosh and maidenhair fern, plan a return visit to the site at the close of April to witness Vermont's finest bloom.

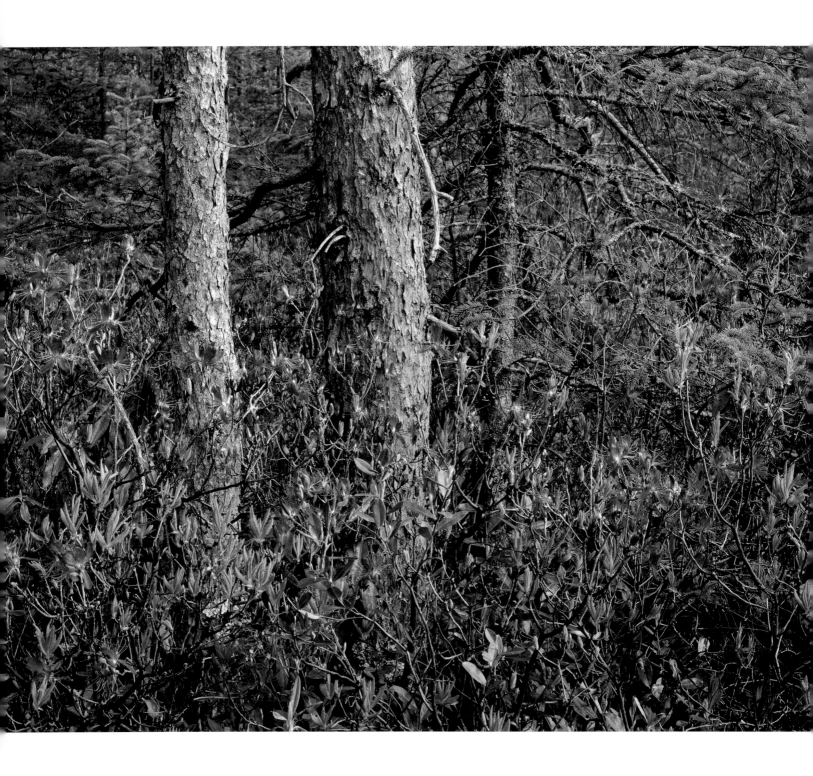

When our hiker moves into a more acid-sited, nutrient-poor forest, such as one dominated by white pine, red maple, and red oak, she will encounter a whole new host of vernal wildflowers: trailing arbutus, starflower, Canada mayflower, dwarf ginseng, pink lady's slipper, and fringed polygala. These species bloom a few weeks later than their rich-sited counterparts. The first four sport white blooms to attract moths. The trailing arbutus has the added advantage of a honeysuckle-rich scent to help moths find its ground-hugging blossoms. The polygala—also called gay wings—shares the rich rose pink of the lady's slipper and is an exquisite small blossom. Like the pink lady's slipper, the polygala also has a rare pure white variant.

Entering valley floors, the hiker will encounter wetlands: bogs, swamps, and marshes. In bogs with some nutrient enrichment, often classified as fens, she may want to wait until early summer to catch the impressive bloom of orchids, with possibly the most dramatic flower of them all—the showy lady's slipper. Like the pink lady's slipper, the showy is a pollination trap, not unlike a lobster trap. The pollinator crawls into the slit on the top of the slipper, which then restricts its exit. The insect has to struggle through a tight tunnel just below the flower stem, where it gets a pollen sack glued onto its back. If the hapless creature ventures into another lady's slipper, the crawl through the tunnel results in cross-pollination.

Or our hiker may venture onto an ancient river delta with well-drained sandy soil. Here she may find a fire-prone forest dominated by pitch pine and carpeted in low-bush blueberry and black huckleberry.

WEST MOUNTAIN WILDLIFE
MANAGEMENT AREA, DENNIS POND

Rhodora, a low shrubby plant that flourishes in boggy areas around Dennis Pond, likes having its feet wet. Appearing in late May and June, its bright magenta flowers are a colorful beacon in the dark boreal forest.

These three species are the most fire-adapted plants in Vermont. Blueberry and huckleberry clone through underground stems called rhizomes. Able to withstand temperatures up to a thousand degrees Fahrenheit for a minute, the rhizomes are the plants' chief adaptation to fire. Hot fires kill all other shrubs, but these two heaths not only survive underground through their rhizomes, but actually increase the area of their holdings.

The pitch pine, with thick, coarse bark that protects it from the heat of a blaze, is New England's most fire-adapted tree. Associated with the coarse bark are tufts of needles that grow out of the trunk and branches and make the tree look rather scruffy. The tufts harbor adventitious buds that remain dormant, protected beneath the bark. If a fire is hot enough to kill the trunk of a pitch pine, the tree can stump-sprout via the buds. Pitch pine is the only conifer in New England that stump-sprouts—an adaptation to very hot fires.

Crossing a river valley, our hiker may encounter a flood-plain forest perched on rich, moist, alluvial silts. These gloriously open forests are dominated by graceful silver maples, underneath which grow six-foot-tall ostrich fern and Canada lily, with its large, classic, yellow, bell-shaped flowers.

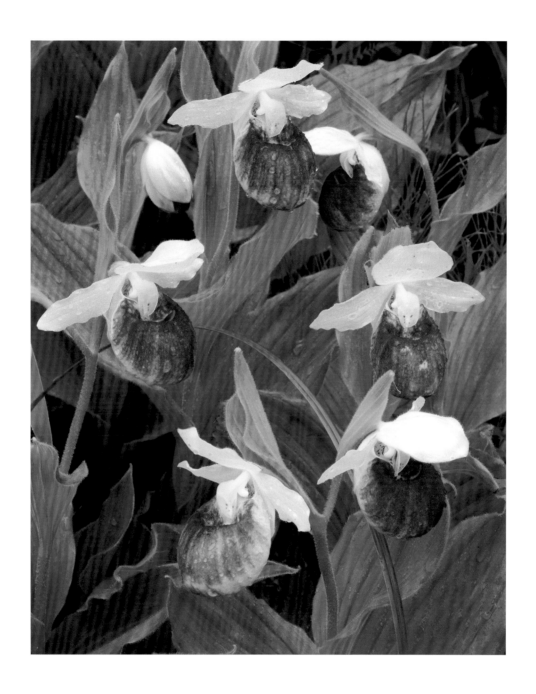

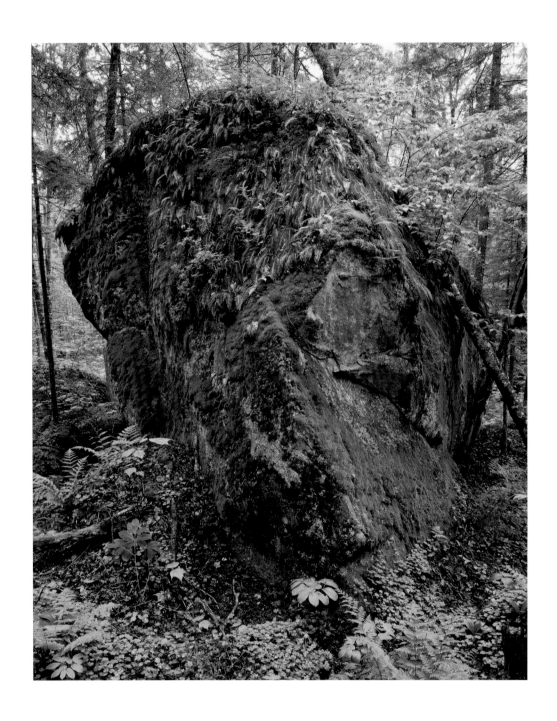

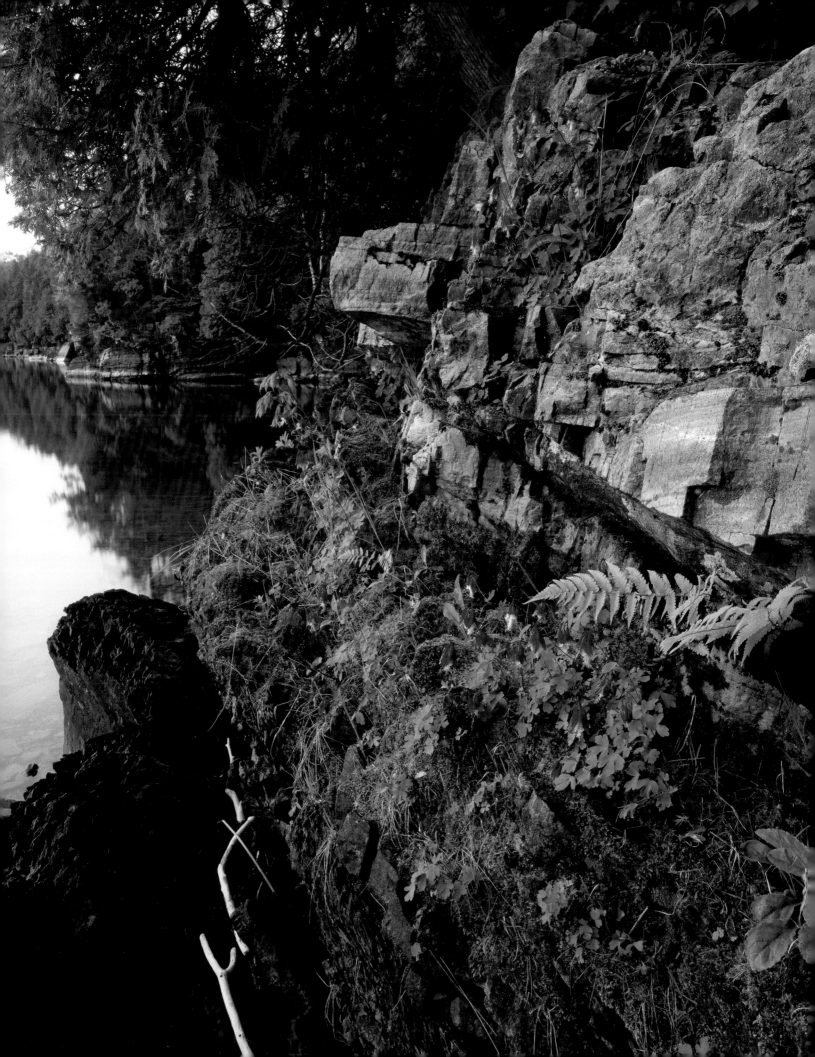

GROTON STATE FOREST, KETTLE POND

*Left behind by melting glaciers,
a mammoth boulder typifies
this forest's primeval landscape.*

KINGSLAND BAY STATE PARK

*Columbines growing along
the edge of Lake Champlain
wear subtle color and begin
to tremble at the slightest
breeze, but soft, even light
and a calm morning allow
for an eight-second exposure.*

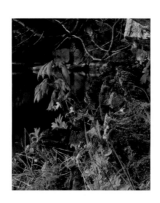

VERNON BLACK GUM SWAMP

*Normally found further south,
Black Gum trees grow here
in swampy hollows formed
by retreating glaciers.
Some of the crooked gums
are hundreds of years old
and many of the oldest
have no tops, which were
destroyed by hurricane winds.*

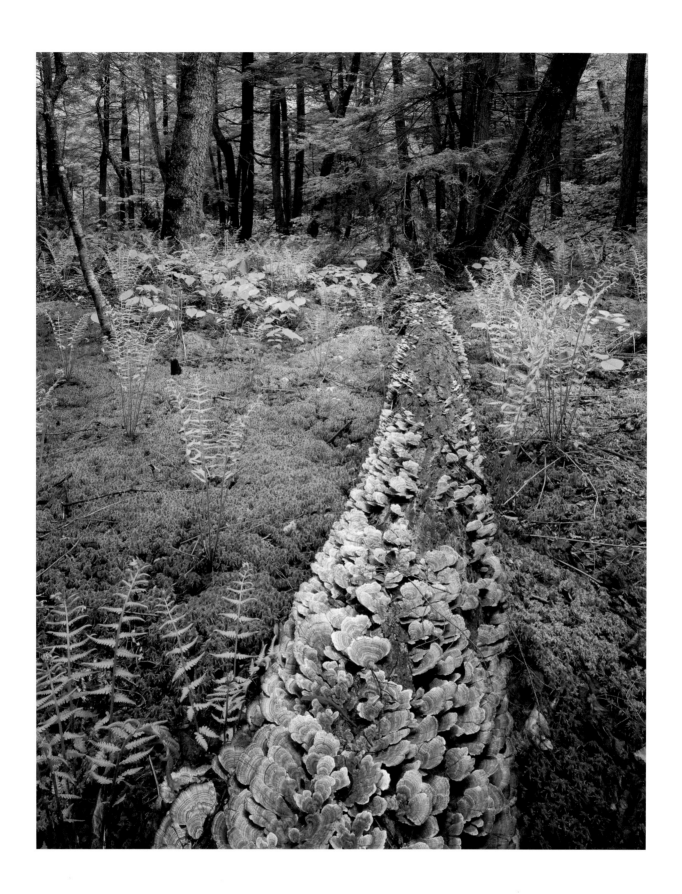

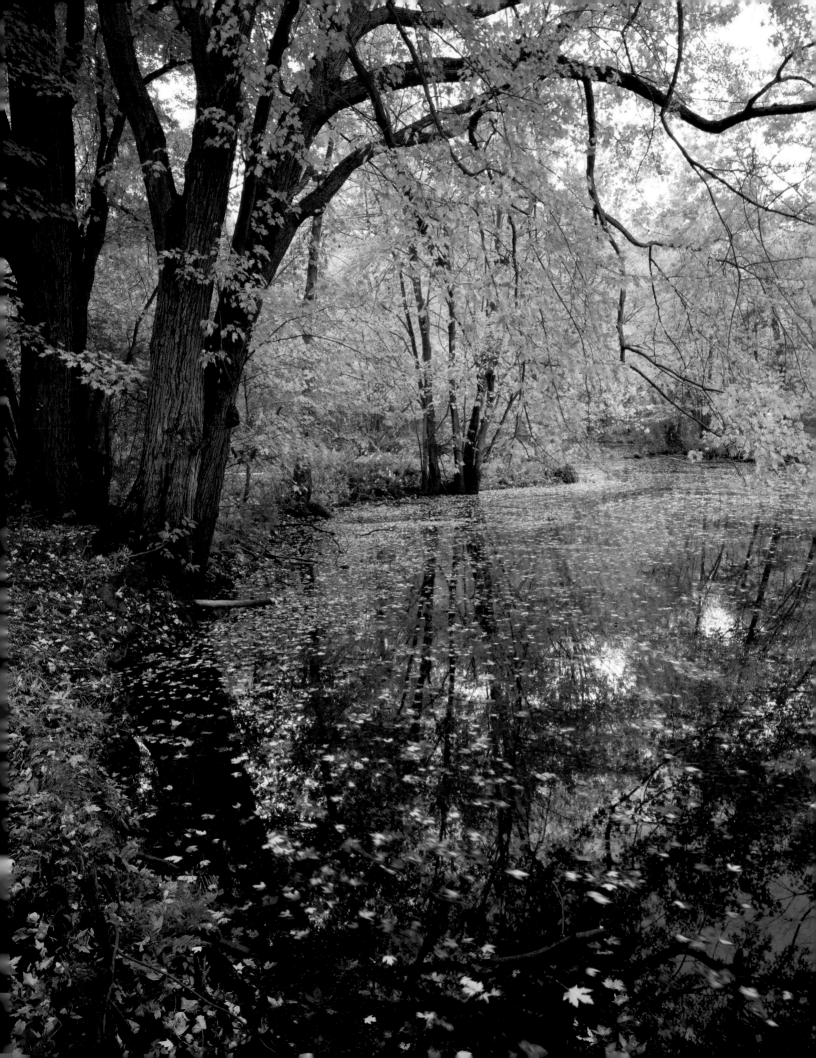

THE OKEFENOKEE SWAMP'S NORTHERN OUTPOST

The five communities just described, plus many dozens more, are expressions of the state's complex physical structure. But it is not solely Vermont's great physical structure that gives rise to so many natural communities. It is also the state's north/south orientation, over latitudes where the two major forest types of eastern North America meet. From southern New England all the way down to Georgia and out across the Mississippi River, the eastern half of the United States is dominated by temperate, deciduous forests characterized by broad-leaved trees that drop their leaves in the fall. From northern New England up to Labrador and westward across Canada, we find coniferous forests dominated by evergreen spruce and fir. Vermont lies in a transition zone between the two forest groups, and as a result of their mixing has a greater array of communities than either adjacent Canada or southern New England.

On Black Mountain in Dummerston, for example, we find southern stands of pitch pine and bear oak reminiscent of the fire-prone Pine Barrens of New Jersey. Yet in the southern Green Mountains, just thirty miles to the west, we find red spruce and balsam fir forest not unlike those hundreds of miles into Canada. In Vernon, in the southeastern corner of the state, we can hike to an ancient black gum swamp with trees up to five hundred years old. The impressively deep bark fissures on the gums

speak to great longevity and slow growth in this ridge-top swamp. Yet black gum is more commonly associated with Georgia's Okefenokee Swamp and reaches its northern range limit in the Connecticut River valley just forty miles north of Vernon.

In the towns west of Vernon, we can head to any number of nearby bogs dominated by black spruce and tamarack, again similar to peatlands found in northern Canada. Such extremes are common in Vermont, where southern and northern communities mix and merge, and even share species. The Champlain basin may be the best area in the state to see that mixing. Since Lake Champlain has such a moderating influence on the climate, southern species often reach their northernmost range limits in the basin— growing close to their Canadian counterparts.

GROTON STATE FOREST,
STILLWATER CREEK

Clad in autumn colors,
Owl's Head glows
in the first light of day.

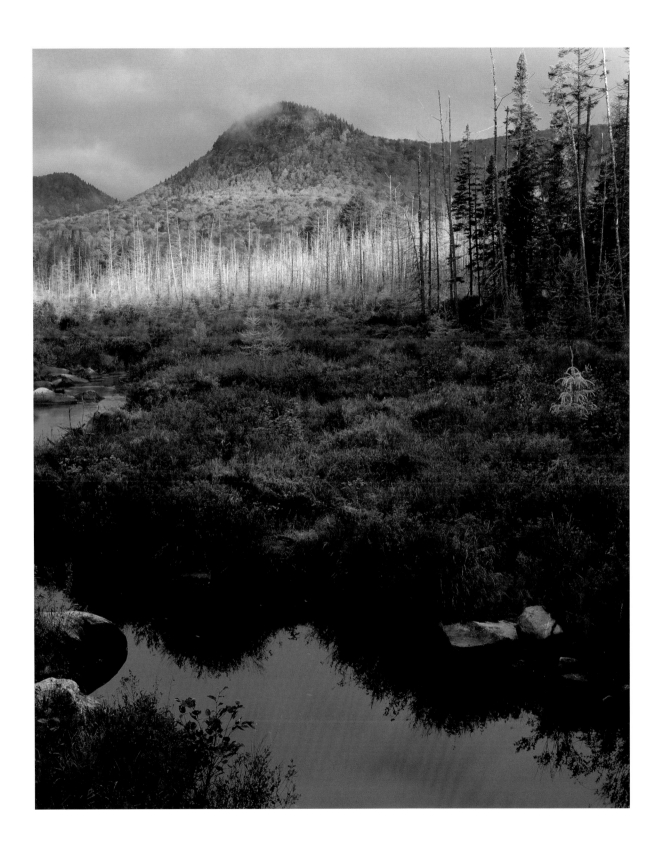

GREEN MOUNTAIN NATIONAL FOREST, BREADLOAF WILDERNESS

*Austin Brook carves
its way through lush forest,
tumbling cold, clear water
over rocks, in a quintessential
Vermont wilderness scene.*

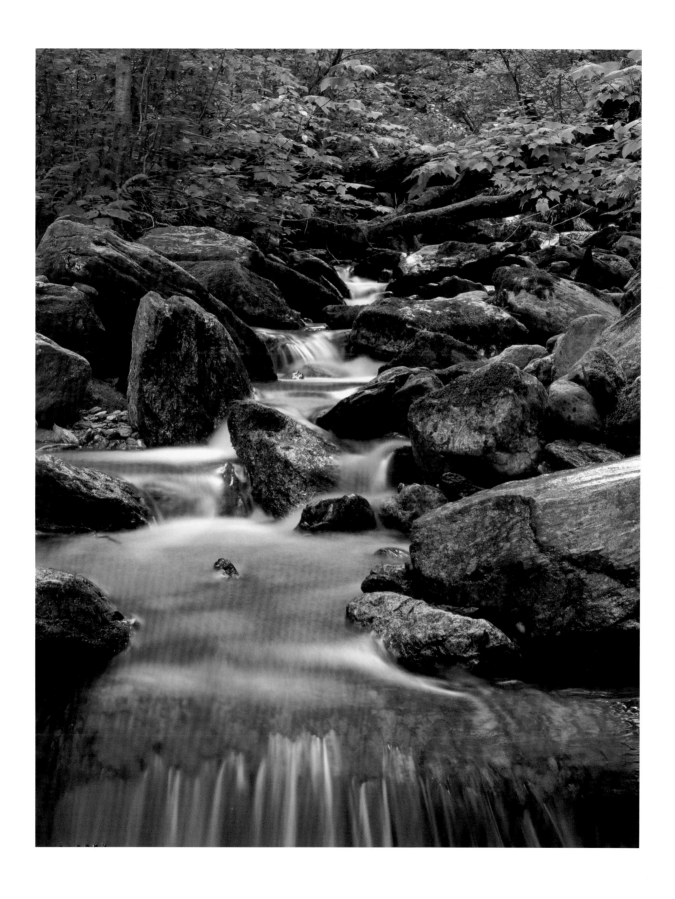

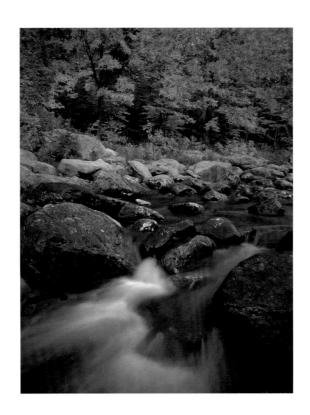

GREEN MOUNTAIN NATIONAL FOREST, DEERFIELD RIVER

*Covering 350,000 acres,
with hundreds of miles
of good trails for hiking,
the Green Mountain
National Forest is the heart
of Vermont's rugged back
country. Parts of the forest
could make valuable
additions to the designated
wilderness system.*

GREEN MOUNTAIN NATIONAL FOREST, WHITE ROCKS RECREATION AREA

*On the Black Branch
of the Big Branch River,
a morning wind showered
autumn leaves onto rocks
in the stream. By afternoon,
calmer conditions made
for a rare picture.*

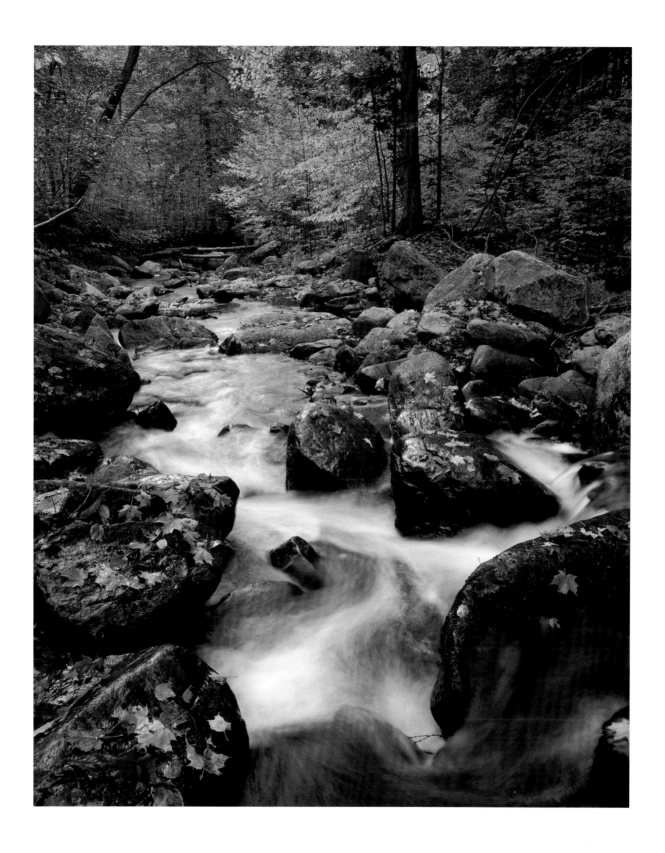

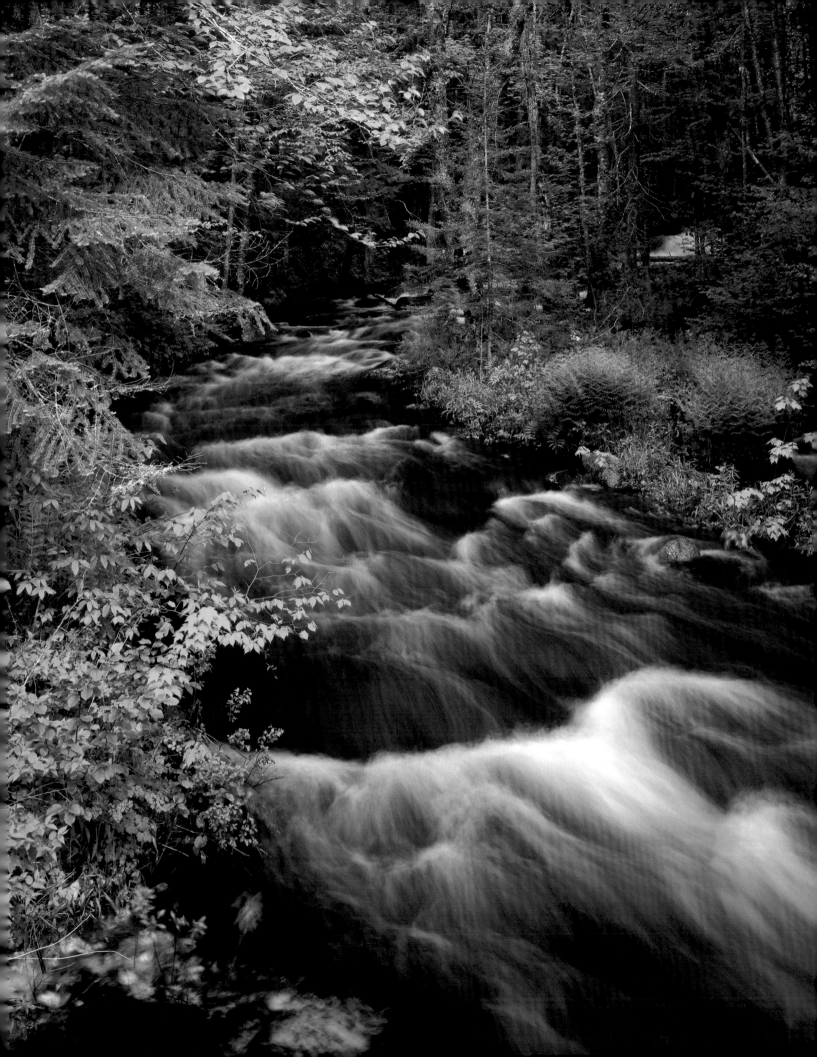

WEST MOUNTAIN WILDLIFE
MANAGEMENT AREA, DENNIS POND

Some spots are still stunningly
beautiful, but logging has
left much of the area adjacent
to Dennis Pond a mess.
Most of the land is cut over,
and not pretty, and with dense
undergrowth, it is difficult
to walk through. Some see the
damage as necessary progress;
others see injury that in time
will heal, especially if a large
area is preserved as wilderness.

TWIN THREATS: EXOTIC PLANTS, GLOBAL WARMING

There is another aspect of the Vermont countryside that directly enhances our perception of its diversity—its four distinct seasons. Cloaked in springtime greens, the deep emerald of summer, fall's flush of yellows, reds, and oranges or a clean white mantle of snow, the landscape displays many different appearances. From the ample pallets of color in spring and fall, the variety of trees in our forests becomes strikingly obvious. Once, during the second week of May, I counted nine different shades of green in the canopy of a mixed forest that covered a hillside in Putney—a testament to the diversity of trees that becomes hidden in the deep green of summer.

The untamed portions of Vermont are not immune to threats to their diversity. Exotic forest pathogens and aggressive exotic plants have seriously impaired the integrity of Vermont's natural communities. Vines such as Eurasian bittersweet can literally kill a forest by covering and choking it the way kudzu can in Southern states. Our rich-sited forests are threatened by thick tangles of exotic honeysuckles, barberries, and garlic mustard, while complex marsh communities may be replaced by monocultures of purple loosestrife or Japanese knotweed. The most visible forest pathogen in Vermont today is beech-bark scale disease. In many of our forests, large specimens of elegant smooth-barked beech are becoming hard to find.

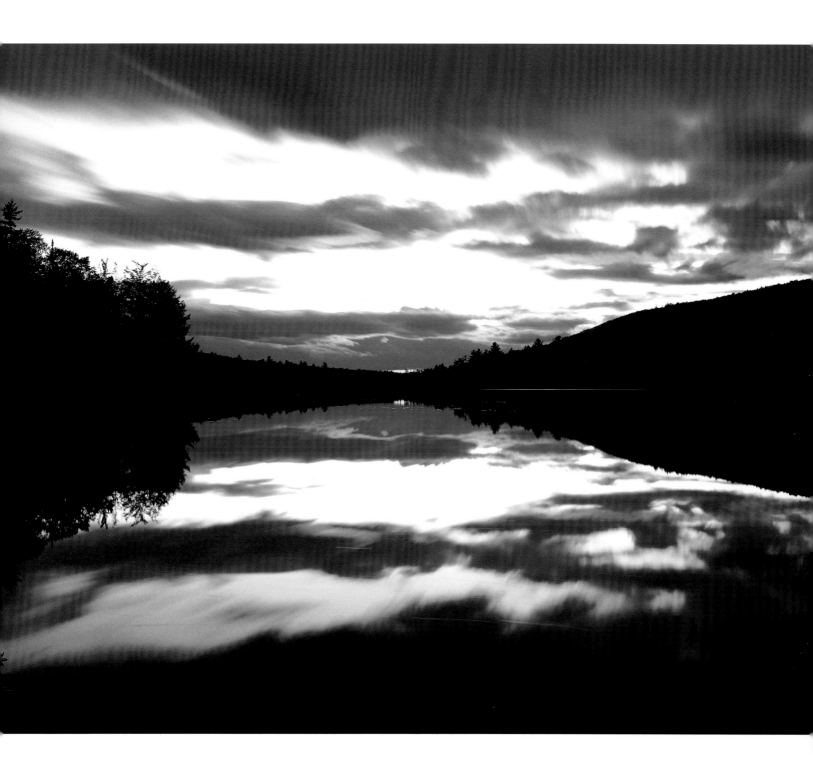

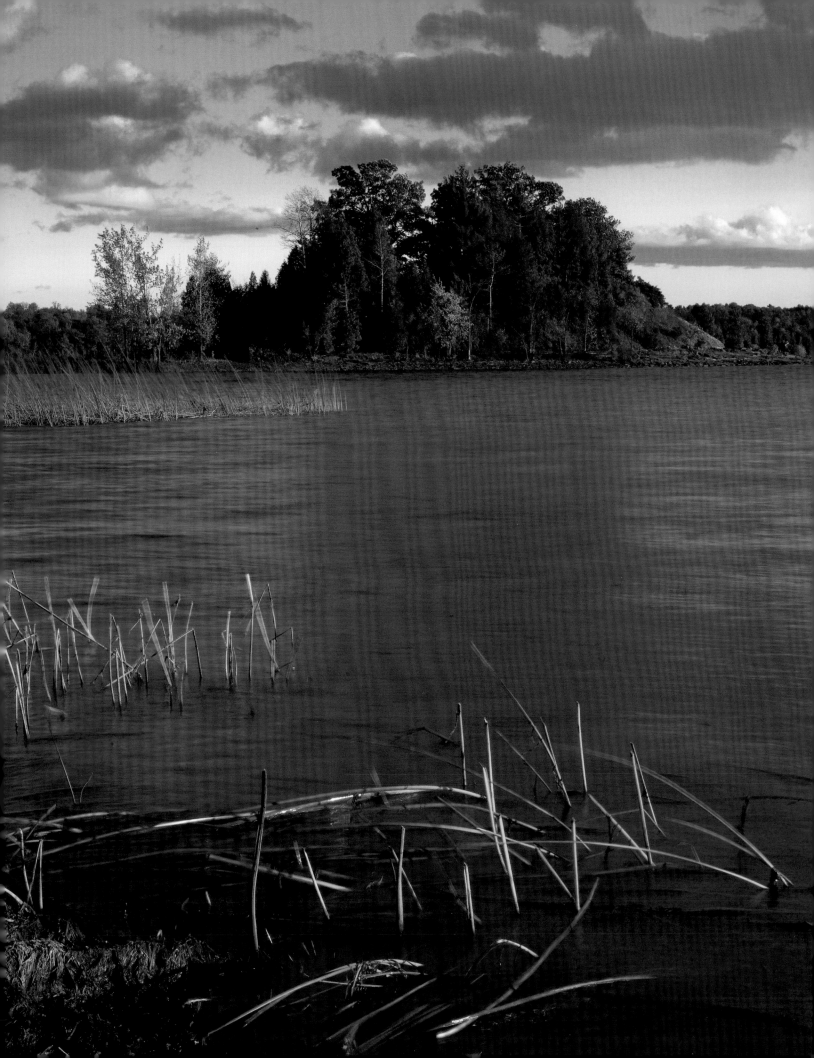

LAKE CHAMPLAIN,
BUTTON BAY STATE PARK

*Along the increasingly built-up
shoreline of Lake Champlain,
Button Bay offers a lightly
developed sanctuary of trails
and, in season, camping and
swimming. The state park
also contains an area with
old trees, plus a nature center
with exhibits on the bay's
500-million-year history.*

Global climate change may aid the march of exotic plants. Although the winter of 2003 was a throwback to the colder seasons of the 1980s, Vermonters have witnessed warming winters over the past decade, with the winter of 2002 being the mildest ever recorded. It was the first winter in my twenty-six years in that part of the state that the temperature not only didn't reach minus fifteen degrees, it didn't even drop below zero. Continued winter warming will open the door to exotic species that have limited cold hardiness. It will also reduce Vermont's biological diversity since many of the state's organisms reside at their southern range limits. Regional warming will extinguish species like sugar maple, paper birch, red spruce, and balsam fir—all hallmarks of the Vermont landscape. Associated with global climate change is atmospheric deposition of pollutants—heavy metals, organochlorines, and acid precipitation. Just as warming climates do, those pollutants stress trees and threaten the integrity of our forests.

When we add increasing forest fragmentation to the list of threats, the future can look bleak. But I am optimistic about Vermont's natural heritage in the long run. As the threats become starkly obvious, I believe that within a decade we will finally begin to seriously tackle climate change and atmospheric deposition as a global community. To combat forest pathogens, researchers are making strides in finding, or creating through hybridization, resistant strains of trees such as the Liberty elm. The Liberty elm is a variety resistant to the Dutch elm disease, a fungal infection that devastated the elms that once graced main streets in many of our towns. Given time, trees that are now suffering from blight will adapt to these new

diseases. Pollen deposits in wetland sediments show that six thousand years ago hemlock was a common tree throughout its present range. Then, starting five thousand years ago, hemlock pollen disappeared from wetland sediments for about a thousand years. It eventually reappeared four thousand years ago. This is strong evidence of a blight that had a dramatic impact on hemlock, but wasn't able to extinguish the species. Finally, people are finding ways of restoring natural communities threatened by aggressive exotic plants.

Just one hundred and sixty years ago, 80 percent of the Vermont landscape was deforested and experiencing massive erosion on hillsides overgrazed by sheep. Growing up in Woodstock, George Perkins Marsh, the father of environmentalism, witnessed the devastating impact of the sheep. Marsh went on to become U.S. Ambassador to Italy and witnessed what centuries of overgrazing by sheep had done throughout the Mediterranean.

His experience inspired him to write *Man and Nature*, published in 1864, the first book to chronicle how human activity can degrade the environment. Although Marsh's work is not well known today, he had a profound influence on many of the country's early environmental thinkers—Gifford Pinchot, Theodore Roosevelt, and John Muir. Luckily, through the writing of David Lowenthal, Marsh's biographer, and the recently established Marsh Billings Rockefeller National Historical Park in Woodstock, George Perkins Marsh is regaining his rightful place in the annals of environmentalism.

After Marsh moved to Italy, his boyhood Woodstock farm was sold to Frederick Billings, a railroad tycoon who had returned to his native Vermont and who greatly admired Marsh's writings. Billings had a strong

Most visitors to the reservoir come to kayak or canoe, some to swim, picnic, or hike the woodland trails. Though the East Shore Trail doesn't quite encircle the reservoir, the hike is perfect for families with younger children. For appreciative parents it also offers scenes like this one of Stratton Mountain.

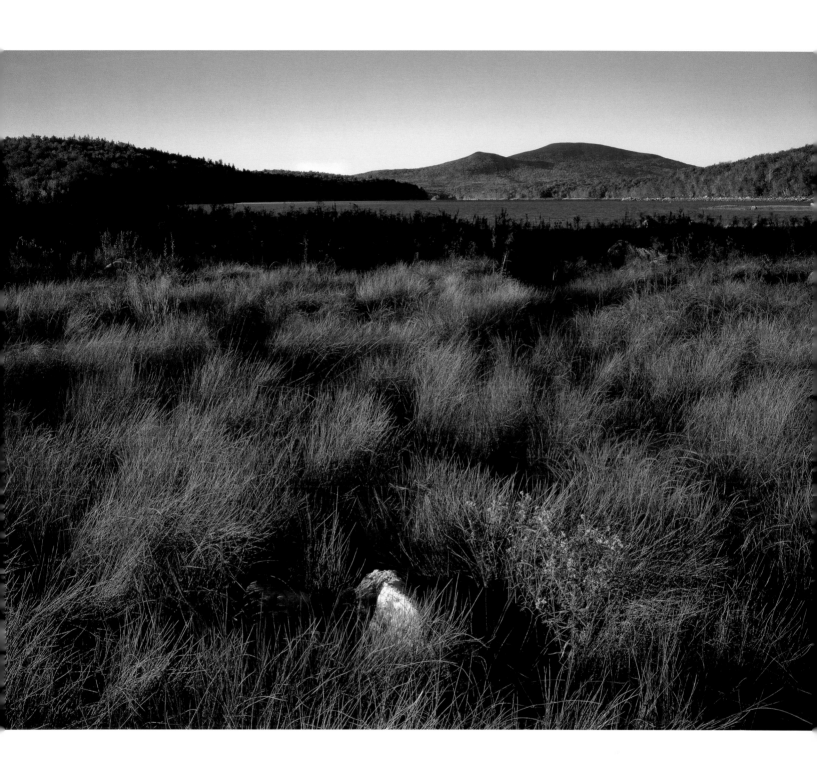

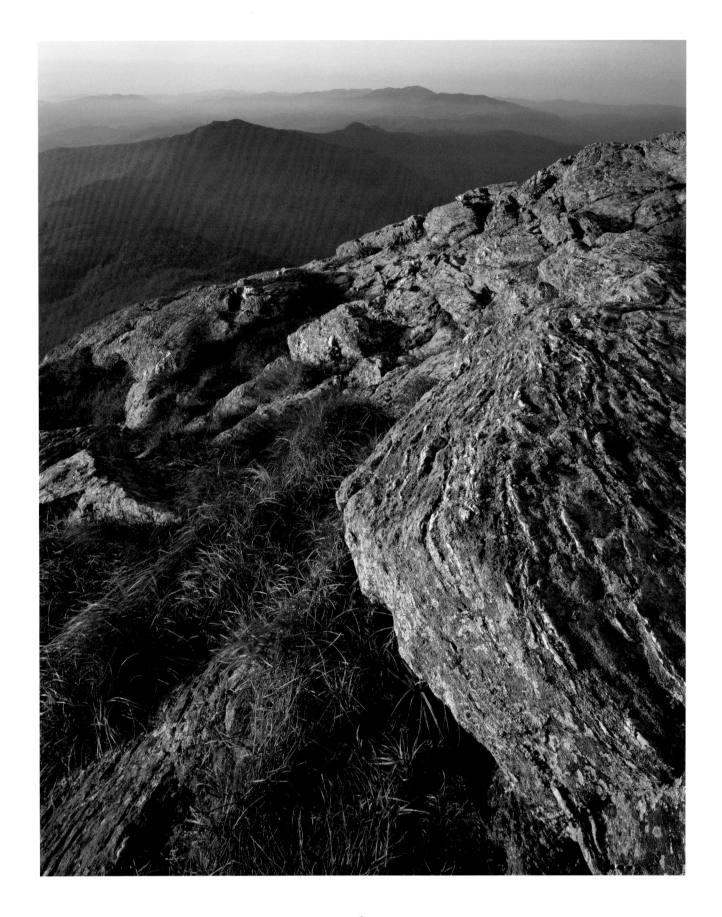

CAMEL'S HUMP NATURAL AREA

A Native American word for the rocky summit area of Camel's Hump translates as "a place to sit upon a mountain." One of the few peaks in the state not disfigured by ski trails or roads, the summit attracts forty thousand hikers a year. For many, Camel's Hump symbolizes the Green Mountain state of mind.

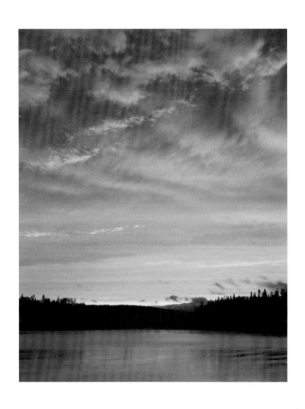

GREEN MOUNTAIN NATIONAL FOREST, BRANCH POND

Encountering the unexpected is one special joy of wild places. At dusk one day, an otter carrying a thrashing fish emerged from the dark water. Scrabbling onto an offshore rock, the slender mammal gulped down its silvery meal, carefully scanned its surroundings, then dove neatly, vanishing into the night.

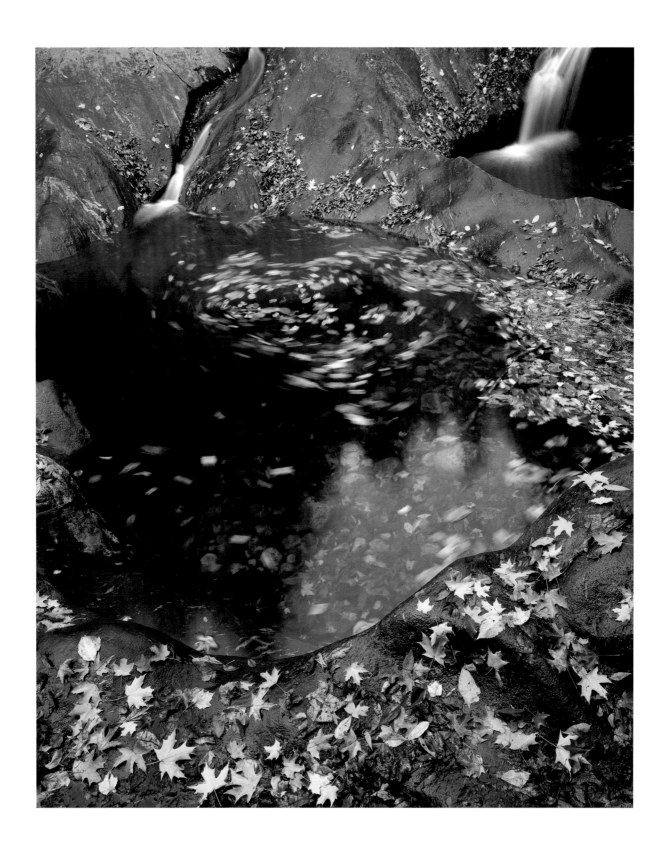

interest in sustainable forestry practices that were being developed in late-nineteenth-century Europe. He dedicated himself to the recovery of the degraded Marsh farm by planting it with trees. In 1874, Billings initiated the first forest plantations grown anywhere in the United States.

Later, Laurence Rockefeller, the grandson of the founder of Standard Oil and son of the great land philanthropist John D. Rockefeller, Jr., married Billings' granddaughter Mary French. Like his father, Laurence Rockefeller believed in both land protection and philanthropy. In 1998, he and Mary gave the Marsh-Billings-Rockefeller estate to the National Park Service to establish Vermont's first national park. The linkage of George Perkins Marsh, Frederick Billings, and the Rockefellers in Woodstock is a wonderful example of how Vermonters have taken leading roles nationally in land protection and preservation.

But efforts to protect the Vermont landscape haven't ended there. Many environmental groups are working to protect and preserve Vermont's untamed landscape. For example, sixteen conservation organizations with varied missions and constituencies have banded together to form the Vermont Wilderness Association, which is aimed at permanently protecting our existing wild areas and expanding wildernesses as well. The constituent members of that group include organizations with a wide variety of purposes, ranging from the Green Mountain Club (hiking) to Forest Watch (restoring wilderness) and the Vermont Natural Resources Council (conservation).

Other state and local groups have already made major strides in protecting our unique natural communities. In my town of Westminster,

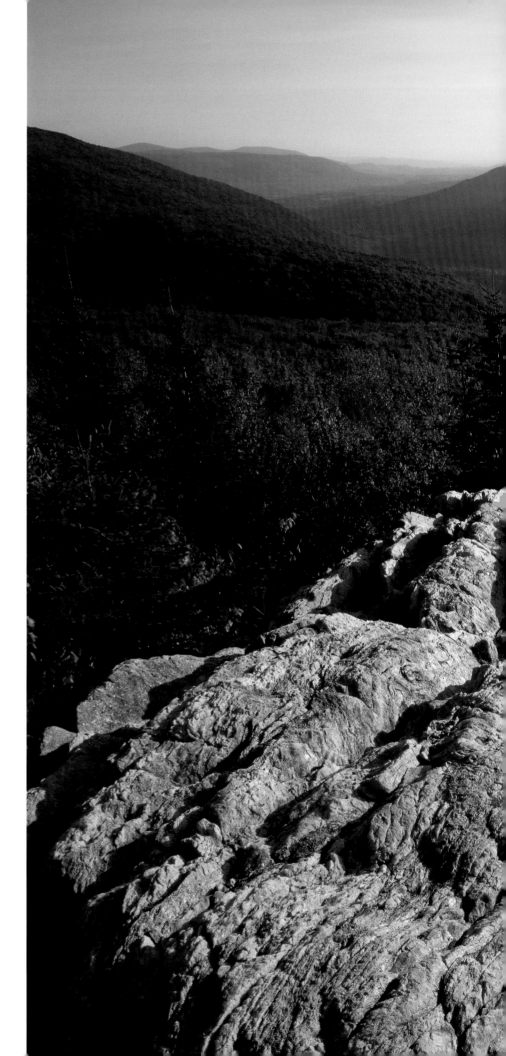

GREEN MOUNTAIN NATIONAL FOREST,
BIG BRANCH WILDERNESS

*Seen from the summit
of Mt. Baker on a late fall
afternoon, hazy shadows
of the Taconic Mountains
are cast across U.S. Route 7.*

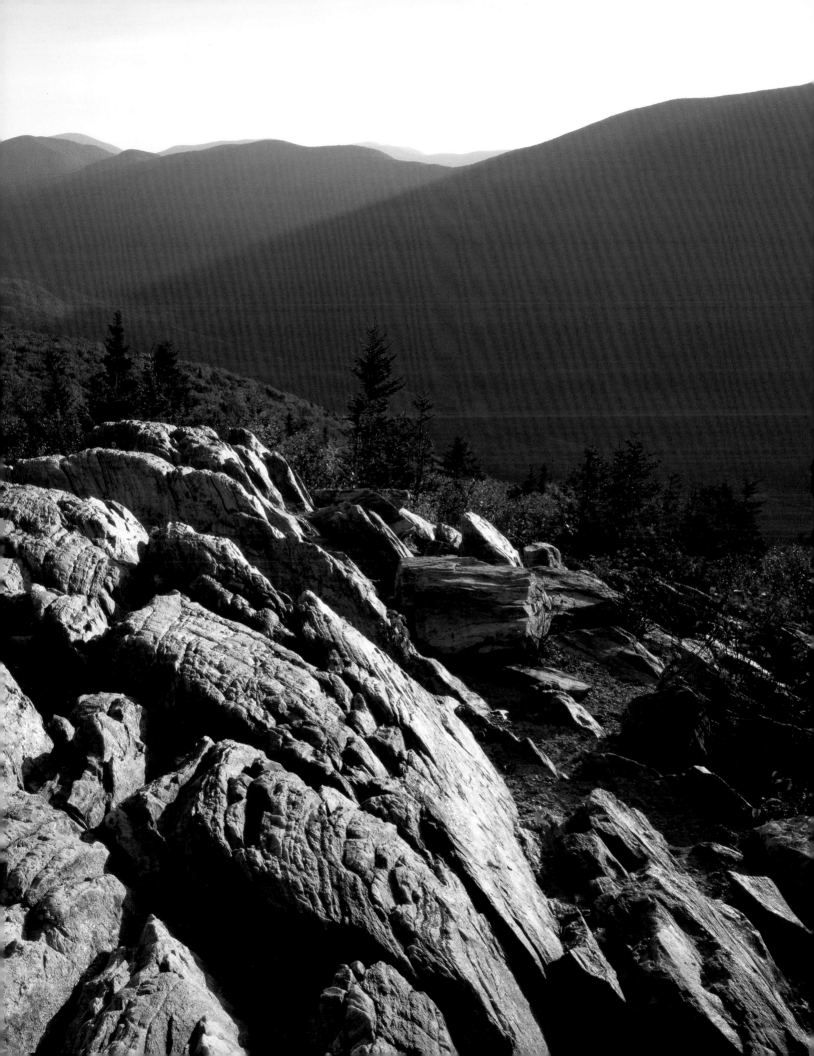

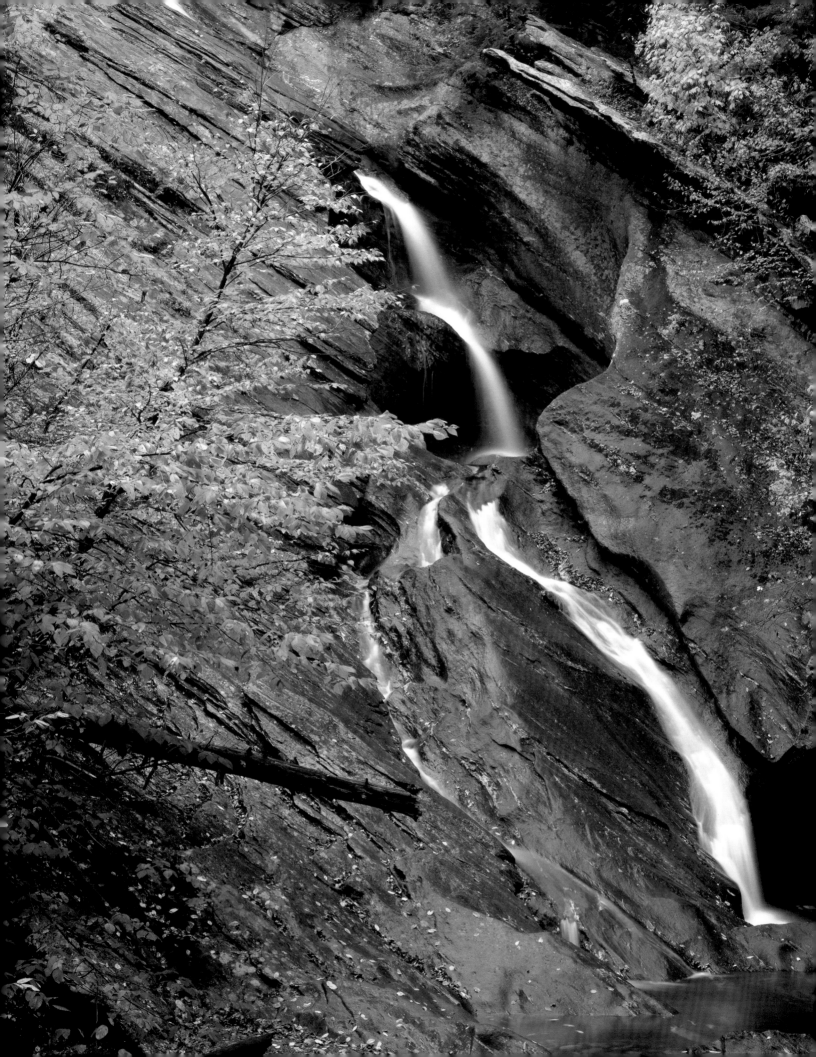

the Windmill Hill Pinnacle Association has protected a ridgeline corridor that stretches from the community of Athens all the way through Westminster. Working together, the Windmill Hill group and the Putney Mountain Association have extended the corridor through much of Putney. Soon the corridor may stretch thirteen miles, all the way to the Nature Conservancy's holdings on Black Mountain in Dummerston.

On the alpine summits of Camel's Hump and Mount Mansfield, summit stewards from the Green Mountain Club are protecting the state's unique tundra communities. The alpine ecosystems are similar in many ways to those found in the Arctic two thousand miles to the north. They can withstand the state's harshest weather, yet are extremely vulnerable to the impact of hiker traffic. Compared to alpine summits in the White Mountains of New Hampshire or the Adirondacks of New York, which don't have summit stewards, Vermont's alpine ecosystems are wonderfully intact. Thanks to their diligence, the stewards have preserved unique communities of dwarf heaths and sedge where alpine shrubs no more than a couple of inches in height can live for many centuries. Although the threats are ever present, much is being accomplished and nature is extremely resilient when given the chance. Our task is to decrease our collective impact to provide our natural communities that chance—for their sake as well as our own.

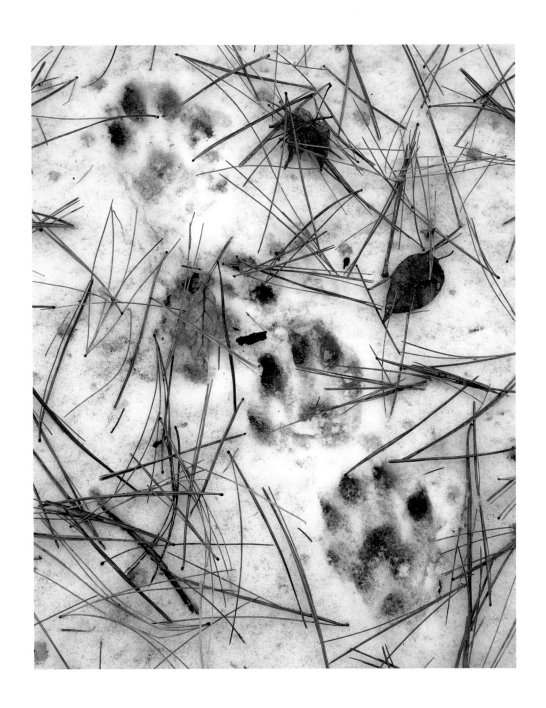

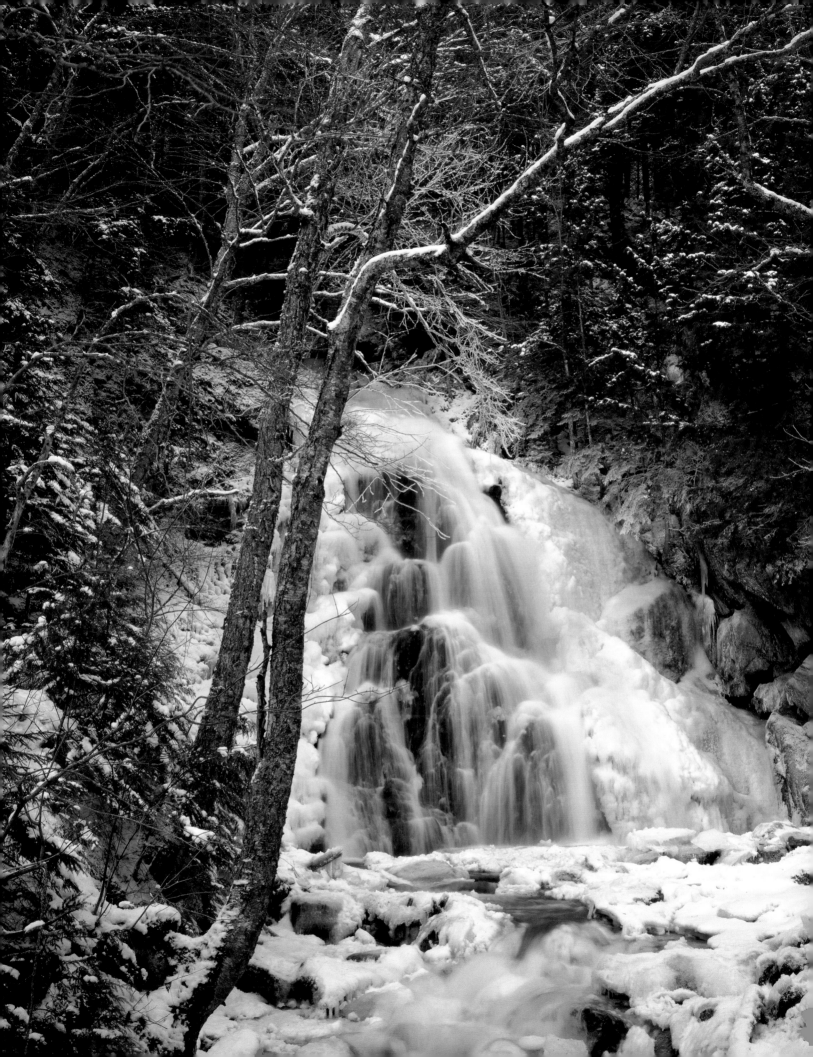

GREEN MOUNTAIN NATIONAL FOREST, GEORGE D. AIKEN WILDERNESS

Minks are rarely observed, but their tracks can be found near water, in mud or snow. Many other animals are secretive or nocturnal, too; their tracks not only reveal their presence but also transform a seemingly lifeless area into a rich home.

GRANVILLE GULF RESERVATION, MOSS GLEN FALLS

Located next to scenic Route 100, Moss Glen Falls appears to cascade directly from the sky. Although it would seem obvious, a warning sign cautions visitors not to climb on the vertical moss-covered falls. Beware in winter, too. Huge chunks of ice can suddenly crash thunderously into the pool at the bottom, causing tremendous waves.

GREEN MOUNTAIN NATIONAL FOREST, BENNINGTON COUNTY

A lone spotlight breaks through clouds to illuminate a fog-shrouded expanse of forest and hills.

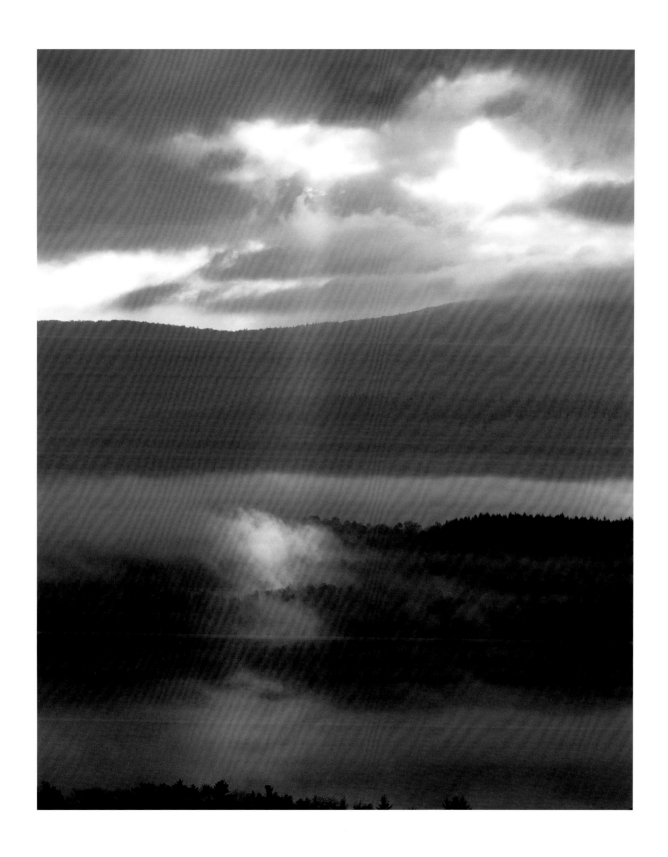

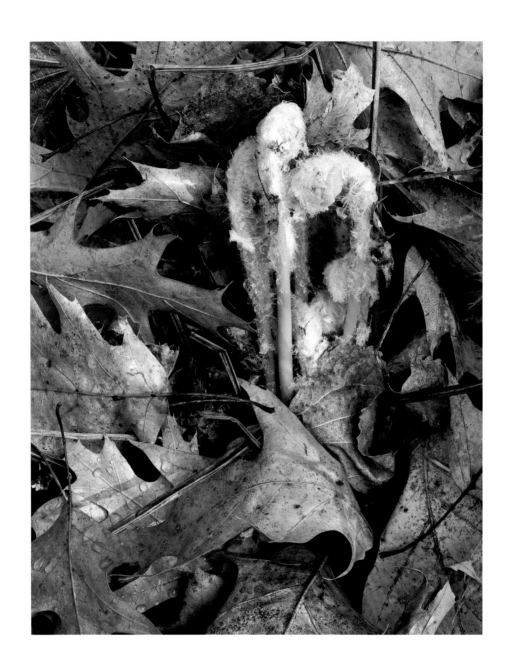

AN INVITATION TO INTIMACY

The photographs in this book can absolutely stand alone in representing and celebrating the compelling aspects of Vermont's natural landscapes. But they also serve as an invitation for each of us— an invitation to become more intimately acquainted with the landscape diversity that Vermont has to offer. As we become more connected to these landscapes, our reverence for them will compel us to work for their protection. I think that is what Blake Gardner is attempting to convey through these photographs—the ability of wild lands to command our respect for nature.

Whether atop a Green Mountain summit, or in a silver maple flood-plain forest of the lower Connecticut River valley, the untamed portions of Vermont speak to us. Cloaked in winter's rime ice, graced by vernal wildflowers, awash with summer's gracious greens, or garnished with the leaves of fall, the natural heritage of this state is rich beyond measure.

All those who experience these special places cannot help but be inspired and fulfilled by the beauty and bounty that continually flows from the cornucopia of Vermont's untamed lands.

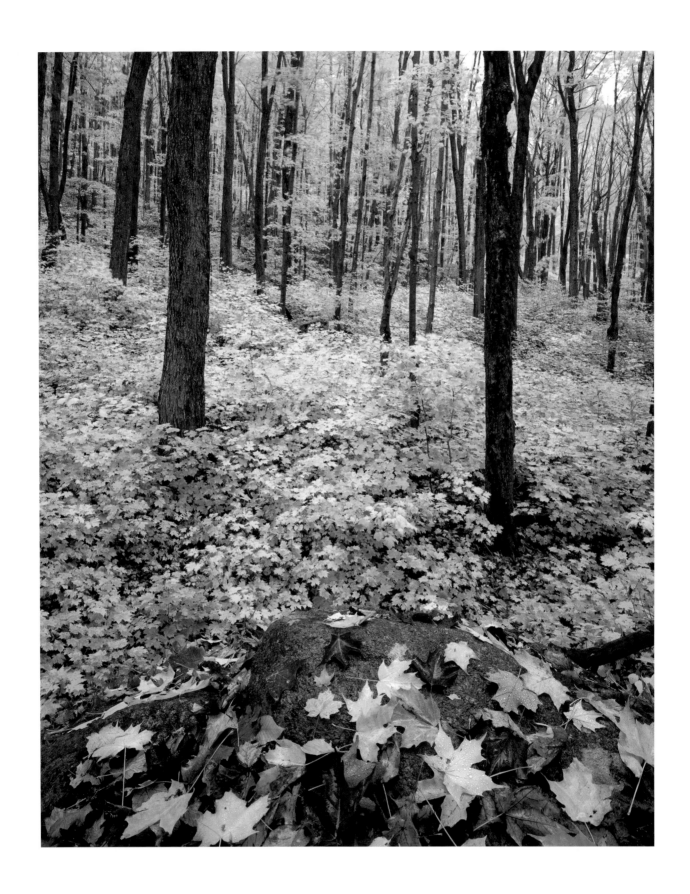

WILLOUGHBY STATE FOREST,
MOUNT PISGAH TRAIL

An even ground cover
of sugar maple saplings
lines Mount Pisgah Trail.
Most people hike this path
for the spectacular vistas,
yet the woods offer their
own dramatic beauty.

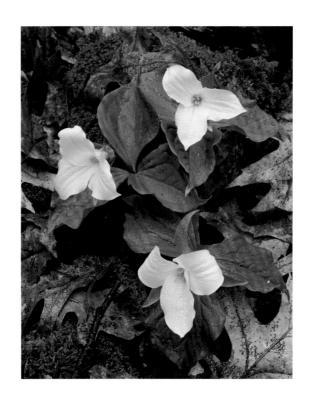

KINGSLAND BAY STATE PARK

Large flowered trilliums are common throughout this park. Here, they bead with moisture after a spring shower.

KINGSLAND BAY STATE PARK

Past a slight rise in the path, thousands of large flowered trilliums seemed to beg to be photographed, even as contrasty light and changing wind made for less than perfect conditions.

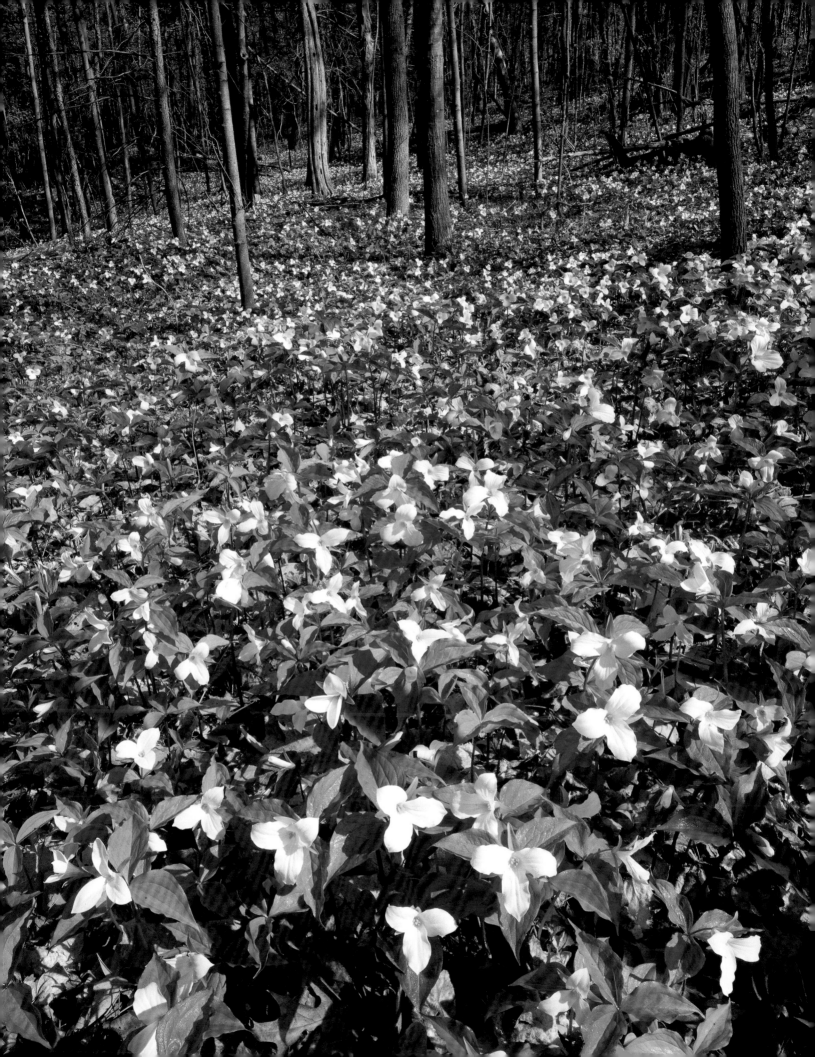

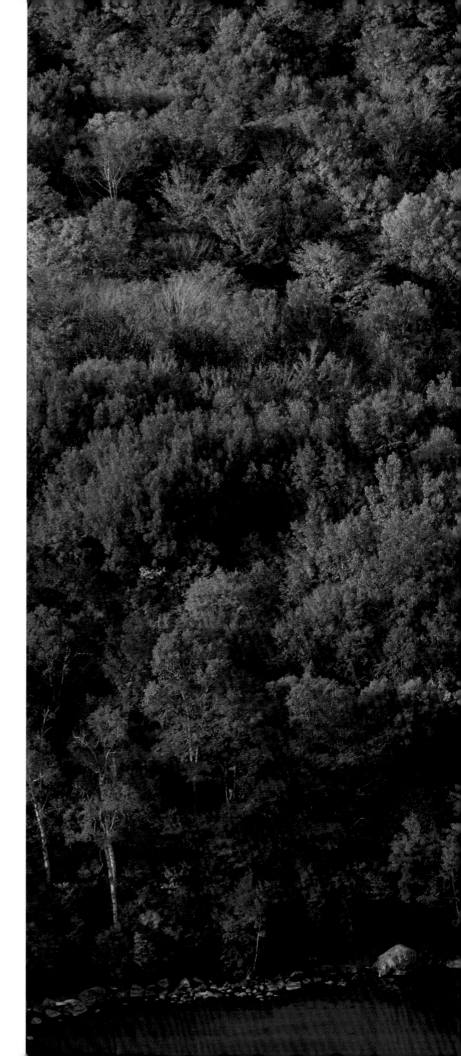

WILLOUGHBY STATE FOREST

A short side trail above
the lake leads to the Devil's
Pulpit, which commands
a 180-degree panorama.
Jutting precariously out
from Mount Pisgah's cliffs,
the small flat perch is hardly
bigger than an eagle's nest.
With a vertical drop-off
of several hundred feet,
the dizzying spot is indeed
more suited for birds.

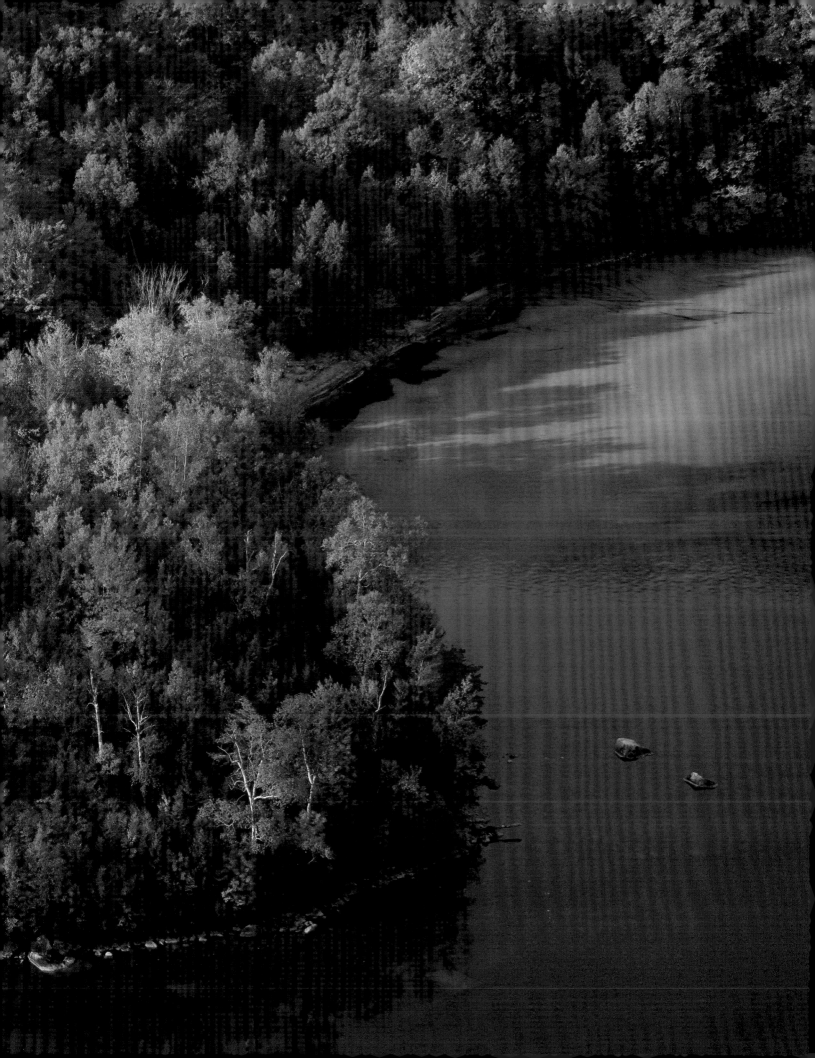

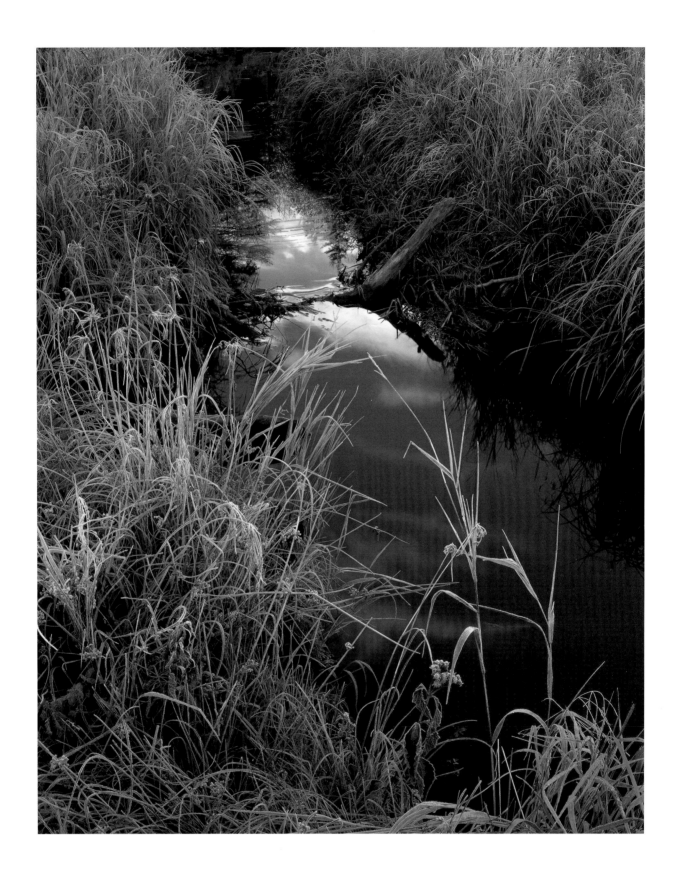

GREEN MOUNTAIN NATIONAL FOREST,
GEORGE D. AIKEN WILDERNESS

*On a still morning, sky
and autumn are reflected
in a beaver channel delicately
lined with frosted grasses.*

LAKE WILLOUGHBY, MOUNT HOR

*Tourist guides dully note
that Lake Willoughby is a
National Natural Landmark
and that it is the deepest lake
in the state of Vermont.
"Awe-inspiring" might be
a more apt description.*

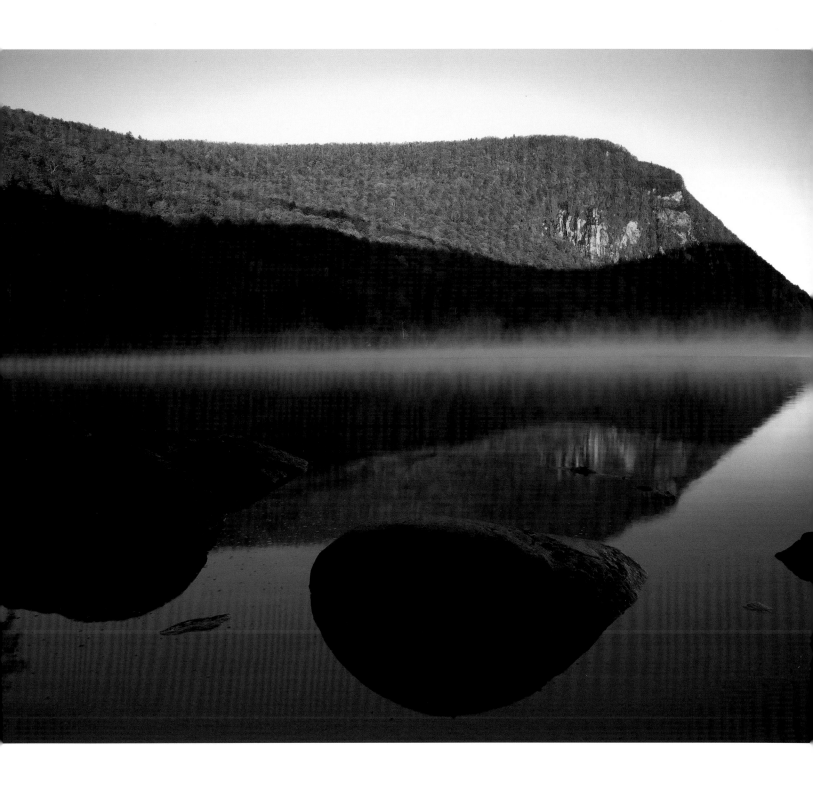

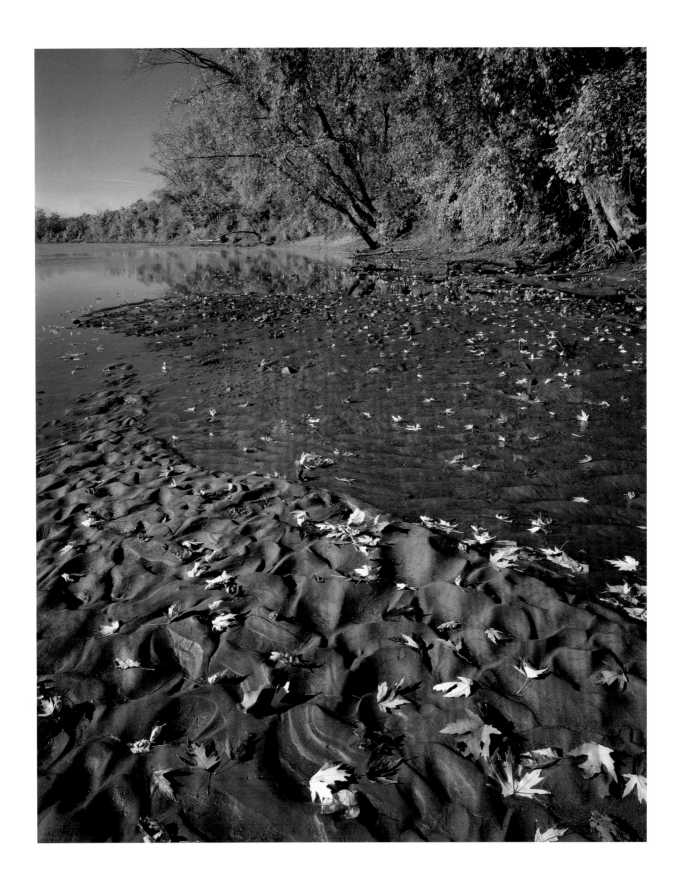

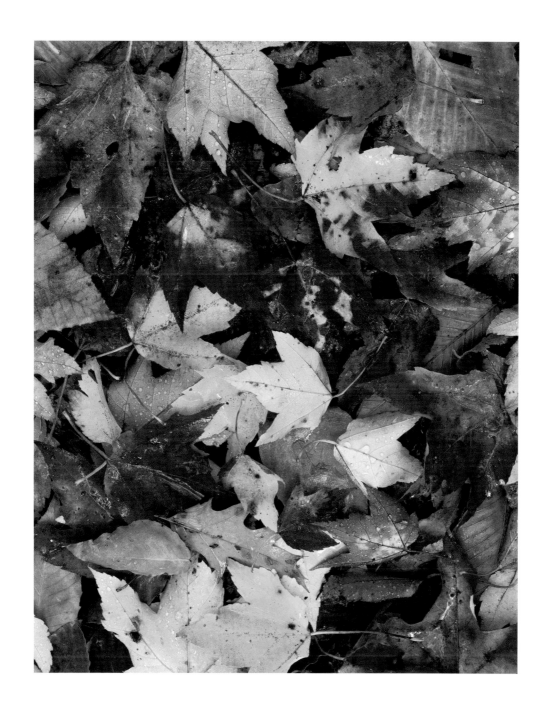

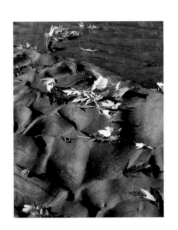

MAIDSTONE STATE FOREST

Although both sides
of Maidstone Lake
are lined with homes,
the state has fortunately
preserved both a park
and forest lands nearby.
Away from the lake,
the land feels truly wild.

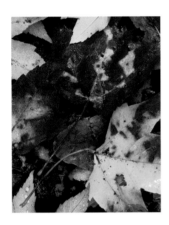

CONNECTICUT RIVER

Curving through rich
farmland, its silty banks
crowned with silver maples
and Eastern cottonwoods,
the Connecticut River
not long ago was log-choked
and highly polluted. It is
a great deal cleaner now
thanks to environmental laws.
Future improvement might
include gentle recreation.
Better access to the shoreline
and the old railroad beds
could provide much-needed
opportunities for biking,
hiking, picnicking, fishing,
canoeing, and other
benign activities.

GROTON STATE FOREST,
KETTLE POND

In what may be Vermont's
easiest hike to spectacular
vistas, a ten-minute uphill
path leads to the rocky
summit of Owl's Head
and its outstanding views
of glacial lakes, dense forests,
plus the unmistakable
silhouette of Camel's Hump
in the distance to the west.

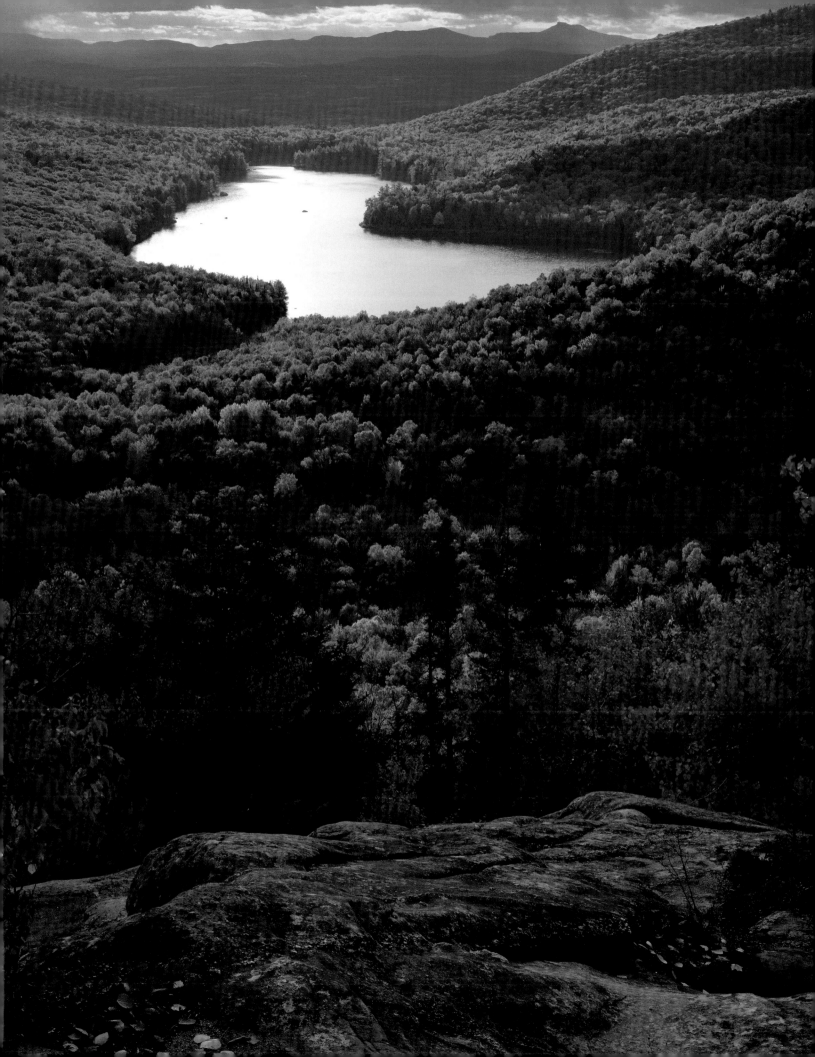